DRAW
CARTOONS

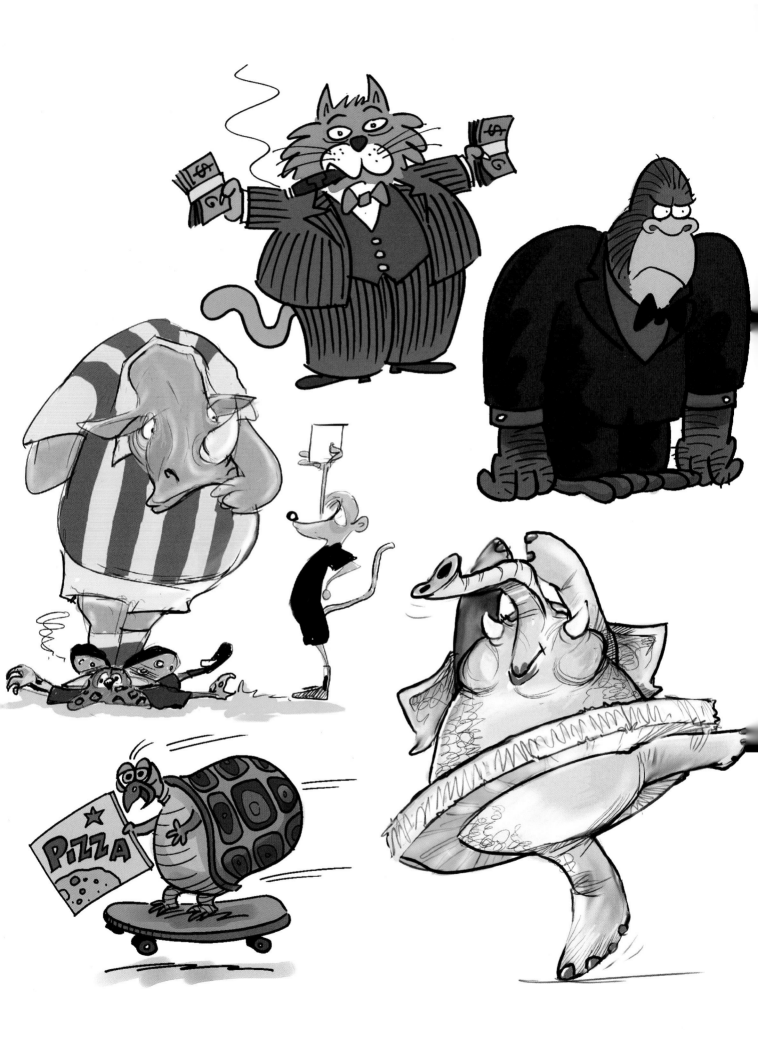

DRAW
CARTOONS

Noel Ford • Pete Dredge • Steve Chadburn

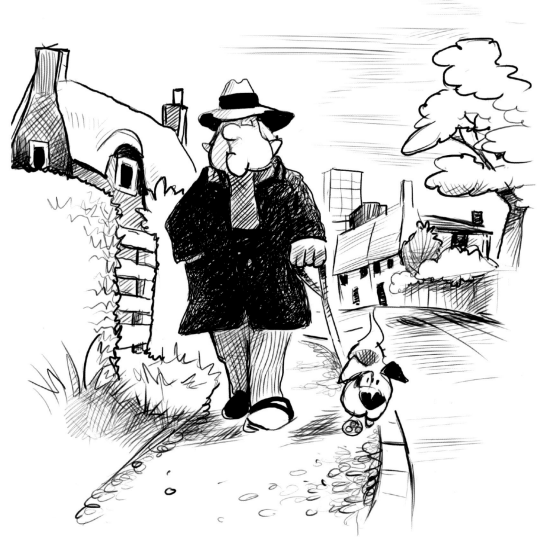

NEW
HOLLAND

First published in 2006 by
New Holland Publishers (UK) Ltd
London • Cape Town • Sydney • Auckland

Garfield House, 86–88 Edgware Road
London W2 2EA
www.newhollandpublishers.com

80 McKenzie Street, Cape Town 8001, South Africa

14 Aquatic Drive, Frenchs Forest, NSW 2086,
Australia

218 Lake Road, Northcote, Auckland, New Zealand

ISBN 13: 978 1 84537 417 4
ISBN 10: 1 84537 417 7

Senior editor: Clare Hubbard
Designer: Adam Morris
Production: Hazel Kirkman
Editorial direction: Rosemary Wilkinson

Reproduction by Pica Digital Pte Ltd, Singapore
Printed and bound in Malaysia by Times Offset
(M) Sdn Bhd

10 9 8 7 6 5 4 3 2 1

CONTENTS

INTRODUCTION

Why do so many people love cartoons? Perhaps it's because the cartoon can say so much in just a few simple lines, deflating, in a stroke or two of the pen, the most pompous politician, getting directly to the point of serious events or, quite simply, making us laugh. Perhaps, also, it's the way that cartoons cross barriers that other art forms don't – being equally enjoyed by people of all ages and from every walk of life.

Cartoons are all around us, in newspapers and magazines, in advertisements, on television, even on our grocery packages! And anyone who has ever doodled on a scrap of paper has drawn a cartoon! Some people, however, want to do more than doodle – they want to learn the skills and tricks that cartoonists use to produce really good cartoons. If that is your wish, then this book is an excellent place from which to set off along that road!

So, why do you want to draw cartoons? Perhaps you want to do it as a hobby; maybe you want to make your own cards or gifts for friends and relatives; you may even harbour the ambition to see your work published. Whatever your reasons, we will guide you towards creating super cartoons.

The best way to use this book is, (believe it or not!) to start at the beginning and work your way through to the end. We say this because we have set out the material in a logical sequence, beginning with the basics and gradually progressing to look at the different ways that you can embellish and improve your drawings. Let's take a very brief tour and view some of the points of interest along your way to accomplishment in the skills of cartooning.

After a short discussion on the nature of cartoons, we get started on a close examination of the materials available for drawing them. There are

few absolutely right and wrong materials but some are a lot more suitable than others and, amongst these, there are some that will suit some cartoonists more than others. The choice of materials, ranging from the simple pencil through to the digital power of the computer, is, then, quite subjective – but by presenting you with a broad spread of choices, along with pointers as to the strengths and weaknesses of individual materials, you should be able to experiment and find the materials that suit you best.

Having shown you the different materials you can draw with (and upon), we get right down to some actual drawing. We take you through the basics of building your cartoon characters, and then bringing them to life, using such things as expression, body posture and movement. Your characters will quickly develop personalities of their own, from subtle to wild.

After this it is time to give your work form and depth and we demonstrate how you can achieve this through the use of the more advanced techniques of shading, tone and colour. Suddenly your cartoons are really beginning to stand off the page.

Up to this point we have concentrated on the central feature of your cartoons, the characters, but it is important to look, literally, at the broader picture, and consider the settings and viewpoints of your cartoon. Therefore, our next stop along the way deals with the overall layout of your cartoon, the important aspect of backgrounds and (take a deep breath!) perspective! Don't be afraid, we're not going all technical on you, merely showing you the tricks of giving your cartoons a true sense of depth.

Next comes the cartooning of inanimate objects and how to give these things personalities of their own. This can be one of the most enjoyable aspects of cartooning and one that is definitely worth the time taken to build up your cartooning skills before you get properly to grips with it.

Our last but one port of call brings us to a few exercises that you might care to try your hand at. In addition to setting these tasks, we also show you how to assess how well you have done. Whilst it is alright to take a quick look ahead at this section you should not, of course, attempt any exercises corresponding to sections of the book that you have not yet read.

ASPIRATIONS

Finally, assuming you are still with us (of course you are!) on this road to cartooning success, we suggest a few of the directions your cartooning might take, be it in a strictly amateur capacity or with aspirations to the commercial. Hopefully, by the time you have reached this point, you will have a much better idea of how you wish to proceed. Whatever your direction, do keep this thought in mind; cartooning may not be quite as simple as it looks, but it is definitely as much fun as it looks!

WHO ARE WE?

A good question – and the answer is, we are three professional freelance cartoonists who live in the United Kingdom but who work for publications and clients around the world. We have been in the cartooning business for a long time, are founder members of the Cartoonists' Guild and a few years ago, were all elected Fellows of the Royal Society of Arts. Between us, we are members of several national and international cartooning bodies, including the British Cartoonists' Association, with its membership limited to 100, by invitation only.

We are firm believers that three heads are better than one, which is why we have come together to create this definitive book about learning to draw cartoons. Allow us to make our own introductions:

NOEL FORD frsa:
www.fordcartoon.com

I always had a great desire to become a cartoonist and I achieved this ambition in 1975 when I was able to make cartooning my full-time profession. I became a regular contributor to the world famous *Punch* magazine in 1976, and was also, for 14 years, editorial cartoonist for a national UK newspaper. I am now editorial cartoonist for half a dozen publications and work for media and clients all around the globe as well as having many of my own books published.

STEVE CHADBURN frsa:
www.steve-chadburn.com

I evolved into a professional cartoon illustrator and caricaturist after cutting my teeth in the traditional comics market, and my long experience covers every kind of publication, national and international, including my own books. I now provide a range of cartoon illustration services for major multinational clients on a worldwide basis and have travelled across Europe and to America and Canada in the course of my cartooning work.

PETE DREDGE frsa:
www.petedredge.co.uk

I achieved a lifelong ambition when the UK's world famous humour magazine, *Punch*, published my first cartoon in 1976. Satire magazine *Private Eye* followed in 1977 and I have been a regular cartoonist contributor ever since as well as having contributed to *National Lampoon*, *Reader's Digest* and many other internationally known periodicals. Since 2002 I have been heavily involved in running one of the UK's biggest cartoon festivals in my home city of Nottingham.

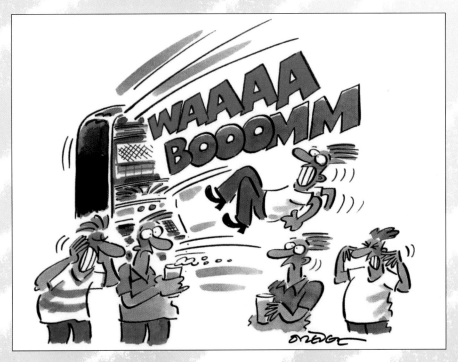

A CARTOON CAN BE ANYTHING FROM THIS...

TO THIS...

...SO THE QUESTION IS...

WHAT IS A CARTOON?

This may seem a silly question – after all, we all know what a cartoon is, don't we? Well, yes, up to a point. But if you are hoping to learn to draw cartoons, before you do anything else you should make sure you know as much as you can about what a cartoon actually is.

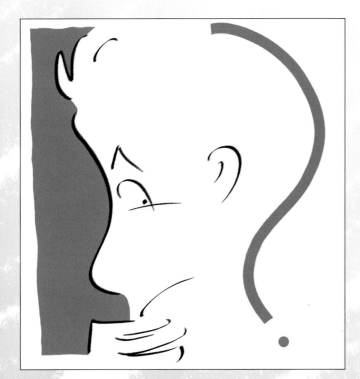

▼ The essence of a cartoon is the reduction of something very complex to a few simple lines. If you think in terms of a join-the-dots puzzle, the cartoon provides the dots and the viewer, albeit subconsciously, joins up those dots and provides the rest of the information that makes sense of the picture. If you find this hard to believe, take a really good look at this cartoon face. The nose doesn't look like a real nose at all, neither does the mouth, the eyes or the ear. And yet we still see it as a face.

In its original form, a cartoon was simply a preliminary sketch – something an artist would do before commencing the actual painting. In other words, cartoons were originally a means to an end. Today, the cartoon has evolved to become an end in itself – many ends in fact, given the great variety of uses to which cartoons are put. Comic humour, humorous illustration, sharp and deadly political comment, sending greetings, good wishes and commiserations, advertising, public relations – cartoons are used in so many different ways.

WHAT'S THE DIFFERENCE?

How then does the cartoon, as we know it today, differ from other forms of graphic art? Take a photograph (not literally, just as an example!) or a realistic drawing or painting. Because every detail is there for the viewer to see, there is no need for the viewer to use anything but their eyes in order to understand what they are looking at. A cartoon, however, demands a lot more from its viewers, even though they may not realize it. This is because a cartoon is not a realistic representation of a person or an object, but an impressionistic one.

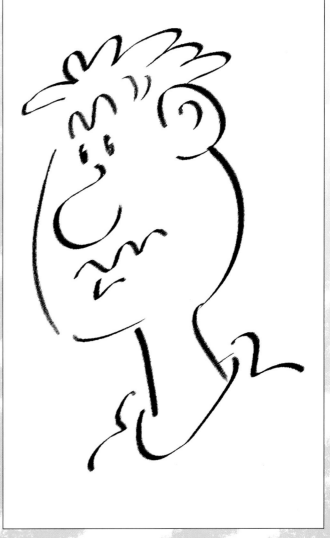

▼ Taking it a stage further, look at these simple shapes. You might even think at first glance that they are letters. In fact, presented in this form, that is exactly what they appear to be, because our mind is programmed to recognize them as such. But suppose we change the way we look at them ...

Or is it? There's no head, no neck, and none of the components look like a real nose, real mouth, real ears, eyes and hair. But we still see it as a face because the way these shapes have been put together has triggered our subconscious into action and it has filled in the gaps to turn the random lines into something recognizable.

Now, clearly, whilst some cartoonists draw in this very simplistic style others draw more realistically. Even so, it's this basic triggering of the viewer's subconscious that is the secret to how well a cartoon works.

IF YOU'VE GOT IT, EXAGGERATE IT!

Once you know this, you can learn how to manipulate your cartoon to make it work even better. If you can spot the main trigger points of your subject, then exaggerating them in the cartoon will make them work even better.

▼ A slightly larger-than normal nose becomes, in the cartoon, an enormous one. If the ears stick out slightly, they suddenly become a danger to passing traffic!

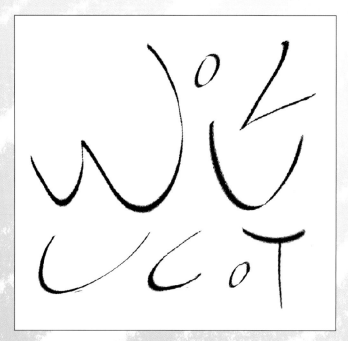

▼ ...and arrange them in a completely different way. Once again our mind tries to come up with something recognizable and this time... it's a face.

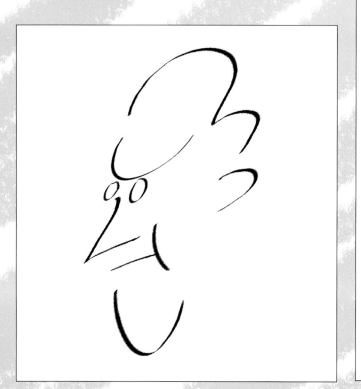

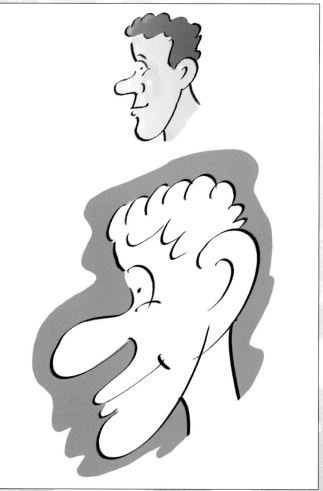

INANIMATE OBJECTS ▶

It isn't just people (and animals) that these tricks work with. Almost any inanimate object will possess similar trigger points that you will be able to manipulate and use in your cartoons. Look at the two examples right, and you will see what we mean.

The car and the boat are easily recognizable despite the fact that they are represented by only a few squiggly lines. As with people and animals, provided the viewer has some subconscious knowledge of your subject, their brain will automatically fill in the gaps.

Now, please understand that we are not suggesting that you should draw as simplistically as this. We have used these rather extreme examples in order to demonstrate the power of the cartoon drawing style. Even if your cartoon style is quite detailed, the same rules still apply:

• Identify the most recognizable features of your subject.
• Make them the key points of your cartoon.

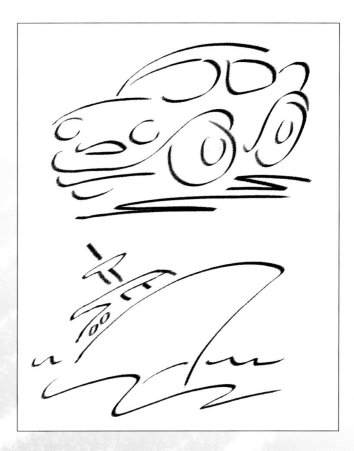

Top Tip

There are few professional cartoonists who can honestly claim that their work is totally original and uninfluenced by the work of any other cartoonist. Influence is unavoidable if you look at other cartoons.

We are not saying that cartoonists deliberately copy other cartoonists' styles, just that sometimes, when we see the way someone else has drawn something, we might be influenced enough to adapt that particular technique into our own style. We might do this consciously or subconsciously.

The point is, that looking at published work is a major factor in the development of any cartoonist. This means you too! So, as you are learning the ropes, remember that just looking at cartoons is an important part of your cartooning education.

WHAT WAS THE QUESTION?

What, then, is a cartoon? In many ways it is really a form of shorthand that everyone knows how to read below the level of normal consciousness. When you look at the two cartoons on page 10, you might think that the detail of the first example, the pirate ships, makes it an exception. Not so. It may be a very complex cartoon but the individual components all follow the same "shorthand" rule. A cartoon, then, whether simple or complex, is a joint effort between the cartoonist and the viewer, each one supplying the information necessary to the success of the enterprise.

GETTING STARTED

WHAT ARE THE BEST MATERIALS TO USE?

If you ask a dozen cartoonists this question, you will almost certainly receive twelve different answers. It's an emotive subject and one upon which cartoonists hold strong views – even now a fierce debate still rages between cartoonists who use computers and those who regard drawing without pen and ink as verging on the heretical!

Some beginners believe (or hope) that there is a "magic pen", known only to professional cartoonists, that will improve their drawing instantly, but that is, of course, a myth. Similarly, the sort of paper those cartoonists use is exactly the same as that which you can buy at your local stationery shop. There is an answer to the question, though and it is: the best materials for cartooning are those that suit you best!

Easy to say, but with the huge range of materials available, you will need a little help to guide you towards discovering which ones will help you to bring out the best in your drawing. It will also be helpful for you to be aware of the general advantages and disadvantages of each possible choice.

WHITE COPIER/LASER/ INKJET PAPER

These are excellent papers both for roughing out ideas and drawing finished cartoons. They are inexpensive and, for best value, should be bought in reams (500 sheets).

Advantages: These papers are inexpensive and versatile, often thin enough to be traced through. They take pencil and ink very well.

Disadvantages: They are easily damaged. Care must be taken when erasing and, if not held down firmly, they are likely to buckle. Thinner and more absorbent papers should be avoided if you intend to use markers because of bleed problems (fuzzy edges). None of these papers are suitable if you wish to use washes because the water will cause the paper to wrinkle.

WHITE A4/US LETTER LAYOUT PAPER

This is a good quality, semi-transparent paper, which comes in pads.

Advantages: Layout paper is thin enough to be traced through and takes pencil and ink very well. There is also less of a bleed problem with this paper when you use markers. Available in pads, it is very portable and the stiff card backing of the pad enables drawing to be done almost anywhere. (Very useful if you want to sit down unobtrusively and draw your friends or relations!)

Disadvantages: It is a lot more expensive than buying paper by the ream and is quite fragile. Because of the transparency, you don't get the bright white background to your drawing that you get with thicker papers.

WHITE CARTRIDGE/ DRAWING PAPER

This too comes in single sheets and in pads.

Advantages: Similar to layout paper but without any transparency.

Disadvantages: It is expensive.

Our Recommendation

One thing's for sure, if you are keen to cartoon, you are going to get through an awful lot of paper. So we would definitely recommend, at this stage, using a cheap but good quality inkjet paper, bought by the ream.

ARTBOARDS

We need to mention artboards but won't recommend them at this stage. They come in the form of a heavy board and are a lot more expensive than paper.

Looking into the future, if you are drawing cartoons to be framed and hung on the wall, artboards are excellent. They accept most media very well indeed and, because they are rigid, they will take washes without any distortion problems.

If, on the other hand, your ambition is to sell cartoons for publication, then avoid artboards altogether – they are very difficult to process because their rigidity prevents them being wrapped around scanning drums.

If you really want to draw on something a little heavier than paper, you should try a light card. The best place to find this is at your local printers. The quality of the card varies quite a lot, so ask for a few samples to try out with your chosen drawing materials.

Top Tip

It is possible to buy very expensive coated paper and art boards – that is paper and boards with a shiny surface – but they are definitely not suited to our purposes here. The glossy coating is not very friendly to many pens and pencils, and is downright hostile to any form of wash (such as diluted India ink, often used to add tone to a cartoon). So whatever your choice of drawing material, avoid coated paper and board completely.

PENCILS

The pencil is the cartoonist's basic tool and is ideal for roughing out ideas, sketching, doodling, etc. In expert hands, the pencil is also an excellent medium for finished art, but at this stage we don't recommend it for your finished artwork. The line produced by a pencil may look quite black but, when compared to ink, it is very grey and it will be easier for you, as you proceed through the first stages of cartooning, to use something which will give you a much bolder line.

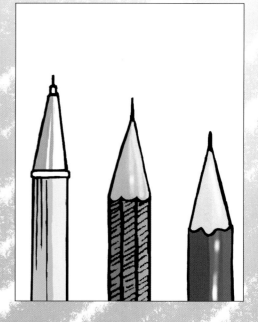

Advantages: Provided you choose a fairly soft lead (between HB and 3B), the pencil produces a good continuous line that is easy to erase. It is quick and simple to use. You can rough out your drawing in pencil, ink over it and then erase the pencil line (remembering to wait until the ink is dry!)

Disadvantages: Not as bold a line as ink. Also, should you have aspirations to be a published cartoonist, pencil does not reproduce well and is not favoured by the majority of cartoonists as a tool for finished art.

ERASERS

All erasers, to a certain extent, damage the surface of the paper. To minimize this, always use a soft, good-quality eraser that will remove pencil lines without harming the finished linework.

It is worth mentioning here that a little forethought when using a pencil to rough out a cartoon goes a long way to keeping erasing problems to a minimum. Keep the pencil line light, avoiding excessive pressure, so that less work is needed from the eraser to remove it.

DIP PENS AND INDIA INK

The dip pen has been around for a very long time and is still, surprisingly to some in this highly technical age, the preferred drawing tool of many cartoonists. It is fair to say that the dip pen is a very personal tool and whilst some people absolutely swear by it, others loathe it. More than any other tool, with the exception of the brush, the dip pen will strongly influence your drawing style.

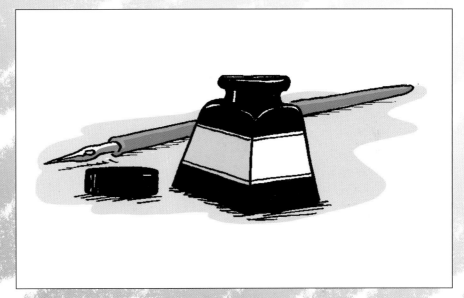

Advantages: The dip pen is inexpensive and economical to use. It is very responsive to pressure, giving a line width varying from fine to broad with the same nib. Used with waterproof ink, it produces a very strong black line that not only looks good but is excellent for reproduction, be it for photocopying, computer printing or commercial printing and publication.

Disadvantages: Ink splatter from a dip pen nib can ruin your artwork! Similarly, working with an open ink bottle is inherently dangerous for amateur and professional alike. One of the biggest problems is that of a non-continuous line – ink can (and will!) run out at the most inconvenient moment.

Sadly, shops stocking this type of nib are becoming increasingly hard to find and nowadays the simplest way to track them down is via the Internet.

The dip pen demands perseverance and a great deal of practise is necessary to acquire a good technique. Heavy ink deposits mean that, in a careless moment, artwork can be smudged. The dip pen is not a good tool for doodling or the quick scribbling out of rough artwork.

Top Tip

When working with an open ink bottle, place it in another, more stable container, such as a small dish, so that any spillage is controlled.

FOUNTAIN PENS ▶

Fountain pens are excellent tools for both finished art and roughing out ideas. If you like a little flexibility in your linework, but not as much and with more control than a dip pen, then this is definitely worth considering.

Advantages: Continuous ink flow and refillable, either with standard black fountain pen ink or a specialist drawing ink produced for use in fountain pens. You get real pen and ink drawing but without the dangers of open ink bottles. Although you may think you need to spend a lot of money to get a good fountain pen, this is not necessarily true. If you can, try out pens with various nib sizes, before buying.

Disadvantages: You must never use waterproof ink in a fountain pen. Also, filling from a bottle can leave you with inky fingers (though you can buy fountain pens that are cartridge loaded). Because the ink does not dry immediately, there is a risk of smudging your artwork.

◀ ART PENS

This type of pen can be found in many art shops and also via the Internet. They come with a variety of nib sizes and are cartridge loaded.

Advantages: Art pens have all the advantages of the fountain pen.

Disadvantages: They are not refillable from a bottle, so you need to have a good supply of cartridges to avoid running out of ink in the middle of a cartoon when the art shop is closed. Buying ink in cartridges is more expensive than buying it in bottles.

FIBRE-TIP PENS ▶

Like the roller ball pen, they are cheap and readily available. Their advantages are similar, too. Although fibre-tips can give a more variable line than a roller ball, the tips wear out quickly and the line gets coarser with use. As with the roller ball, they are fine for sketching but not good for finished cartoons.

TECHNICAL PENS ▶

These pens maintain a very accurate and consistent line width and are very good for cartoon lettering.

Advantages: They are cartridge loaded and the tubular nibs come in a variety of sizes, all of which give you a consistent line width that is excellent for lettering.

Disadvantages: As the name implies, these pens come into their own in the technical drawing field. However, the lack of flexibility makes them unsuitable for creative drawing and they tend to block up easily. To unblock these pens requires a vigorous shaking and you could end up with a nervous twitch!

◀ ROLLER BALL PENS

Good for roughing out ideas and doodling, but not recommended for finished artwork.

Advantages: They are cheap and cheerful, available everywhere and have their own supply of quick-drying ink.

Disadvantages: The line produced by these pens is not variable and the ink is not very good quality. Although fine for scribbling down rough ideas, they are not suitable for finished drawings.

BLACK MARKERS ▼

Although not good for detailed work, it is always worth keeping a black marker handy for quickly blocking in large areas. Filling in a huge night sky can take a lot of time and ink with the pen you normally use.

◄ BRUSH PENS

Brush pens are useful for specialist subjects, such as a quick caricature, where fairly free and sweeping strokes are required.

Advantages: The convenience of a brush without the mess, as the ink is self-contained.

Disadvantages: The ink quality is poor and these pens have a very short working life. They are not suitable for normal cartooning work.

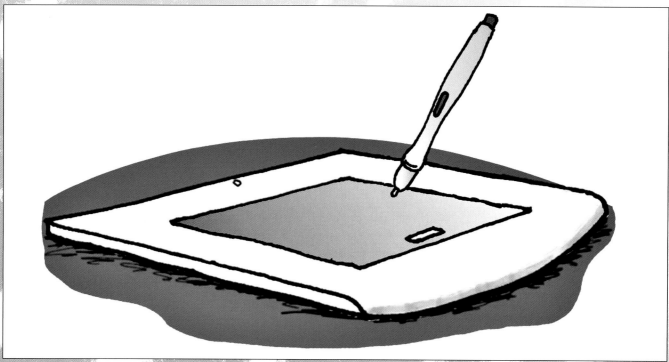

DIGITAL DRAWING TABLETS ▲

Drawing and colouring directly on a computer using a digital drawing tablet is now an accepted way of life for many cartoonists. They are certainly not a cheap option but they are a very convenient way of working for professionals and are fun to use.

Digital pens are cordless, and pressure and tilt sensitive and have the feel of drawing with a normal pen. Used in conjunction with the right software the digital pen can become all of the tools we have mentioned so far plus many more, such as pastel, charcoal and airbrush, and some that have been created especially for digital drawing and painting.

Advantages: You will never have to buy drawing materials again and you will never run out of inks or colours. You can email your finished artwork straight off to friends (or if eventually you want to sell your work, to clients) and you never need worry about knocking over a cup of coffee and ruining your artwork.

Because mistakes are easily rectified, you can experiment boldly in the knowledge that if it all goes wrong you don't have to start from scratch.

Disadvantages: Not only are the drawing tablets expensive but you need to have a good computer to plug them into. Because your cartoons are in digital format, you will need to print them out, so a printer is required too, plus a scanner if you prefer to draw with a normal pen and then colour or shade with the digital pen.

Worst of all, computers can crash or the power can fail and when this happens you will lose everything you have done up to the point you last performed a SAVE.

AND FINALLY...

We have tried to mention as many of the most commonly used materials as we can but, of course, there are many others available with new ones being introduced all the time. As we said, the best materials for you are the ones that suit you, so experiment as much as you can to discover what those materials are. You may find just what you want very quickly but, on the other hand, the drawing tool that will suit you best may not have been invented yet! Try to keep up-to-date and find out about any new materials coming on to the market. Talk to other cartoonists to find out what materials they use.

Meanwhile, all you need as you take your first steps along the cartooning highway, are a pen that you feel comfortable with, and a good supply of inexpensive paper upon which to practise. As you progress further along this road, you will feel the urge to find those materials that are perfect for you and, with the vast amount of art materials that are available, this search might seem daunting and frustrating. Don't worry, this is perfectly normal and you may like to take comfort from the fact that many cartoonists, who have been drawing for years are still searching for that elusive perfect pen!

Top Tip

One of the best (and cheapest) ways to try out art materials is to visit an art show or exhibition where manufacturers are demonstrating their products. These events usually take place in large cities but even if you have to travel quite a way, the experience is normally well worthwhile. You can often find out where such events are taking place by reading art magazines where they may be advertised or featured.

As well as being able to try out new materials, you will very often be offered free samples and the value of these can easily be greater than the price of admission.

GETTING DOWN TO WORK

Whether you want to cartoon for profit or just for fun, it is important that you have a good working environment. This doesn't mean that you have to build yourself a mini studio like the one shown below, but it does mean that you need to be comfortable while you work. If you do have a spare room and the necessary cash with which to set it up as a work space, that's fine, but you can work perfectly comfortably sitting on the sofa providing you follow a few simple rules.

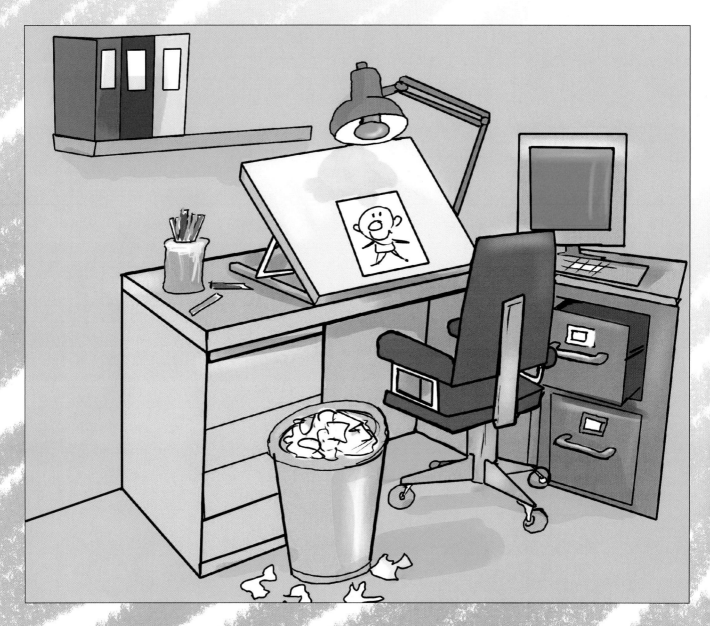

• Some people can work with the television or stereo blaring away whilst others need complete peace and quiet. It really doesn't matter as long as you are comfortable. So, just make sure that you are drawing in the sort of conditions that suit you.

• Remember that once you start cartooning, you will produce a huge amount of work. Don't throw artwork away – what might seem like a poor drawing or lame idea one day may spark off a really brilliant one the next. It's also useful to be able to look back and see how you have progressed. Just a few box files will do to store your work in – they don't take up a lot of room and you can quickly sort through them when looking for something in particular.

• Make sure you have a solid surface to work on. This could be a drawing board (like the one in the picture left), a tabletop or, if you prefer to work on the sofa, a small piece of board or a board-backed drawing pad. Also, remember that it is better to have your work at an angle rather than lying flat.

• There are lots of things that can distract you when you are drawing – sitting in a draught, working in a cold room – whilst not stopping you from working, they will definitely distract you and cramp your cartooning style.

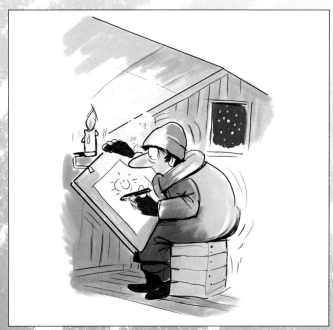

• Whether you work at a drawing board, a desk, a tabletop or on the sofa, it is very important that you work in a good light. This could be from a window, from an ordinary electric light or a desk lamp.

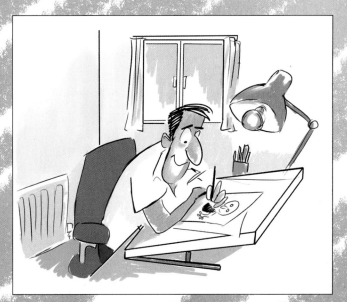

START DRAWING

Beginning with the basics, we'll show you how to make your characters live and breathe and develop personalities of their own (with a little help from you).

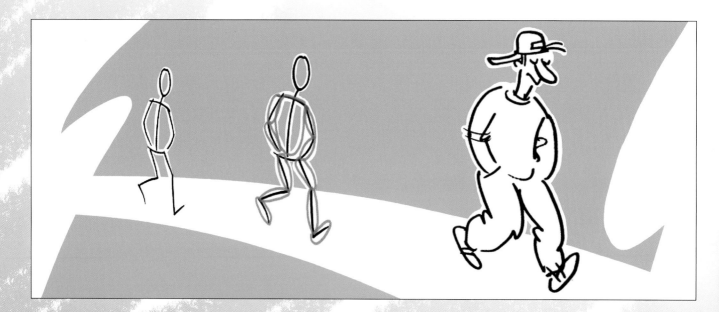

Whether you are an absolute beginner or have dabbled with cartoons before, it's better to start, literally, with a clean sheet and go back to basics. In order to do this, we'll introduce an old favourite in a slightly new guise – the stickperson. This simplified representation of the human figure is a very useful tool and will make it a lot easier to work out how your character stands, sits and moves.

▶ The traditional stickperson is normally drawn like this.

◀ But we are making a couple of slight changes so that our stickperson now looks like this. The addition of shoulders, elbows, hips, knees and feet will make it much easier to pose and move the figure – and to develop it, shortly, into a recognizable cartoon character. So, let's begin with a few variations on our stickperson.

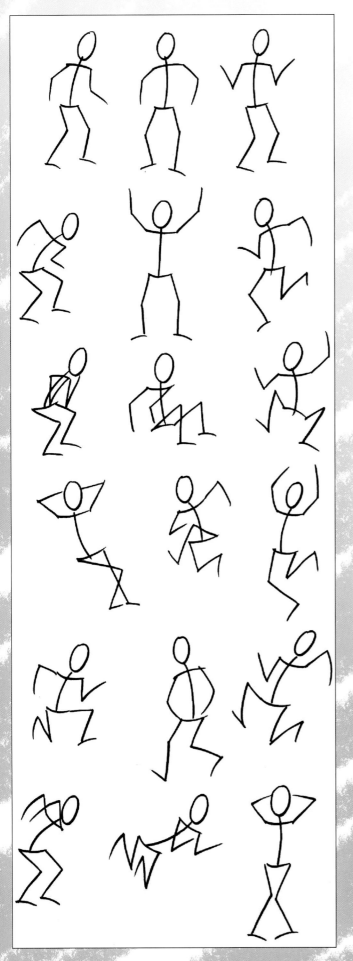

PENCILS READY?

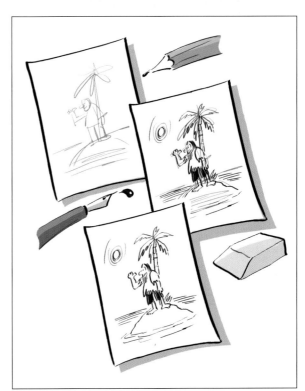

Roughing out is something many cartoonists do when constructing a cartoon. Using a soft pencil, they sketch the whole thing out lightly, ink it over and then erase the pencil.

◀ When you start to draw a cartoon person, you have to make several decisions. What sex? What age? Race? etc. With our stickperson, though, we can get straight into some expressive cartooning and think about those other things later. Look at these examples; you will see that they already possess real character.

Copy them using a soft pencil and then draw some of your own. As you do, you will learn a lot about the cartoon body, its proportions and how everything goes together in a balanced way. It's uncomplicated but it's great fun to do and it will also get you nicely loosened up for the next stage.

TAKING SHAPE

Once you have drawn your basic stickperson, you can begin giving them more shape. Still using your soft pencil (we have used a different colour in these examples for extra clarity), fatten out the various parts of the stick body using balloon shapes. We use the term, balloon fairly loosely – your balloons can be geometrical shapes, such as triangles and rectangles, as well as the balloon-like ovals. Experiment with the shapes – the same stickperson can be adapted in many different ways by simply changing your shapes.

You should also experiment by changing the proportions of the stick-balloon person's body. For instance, try placing the hips much higher or lower.

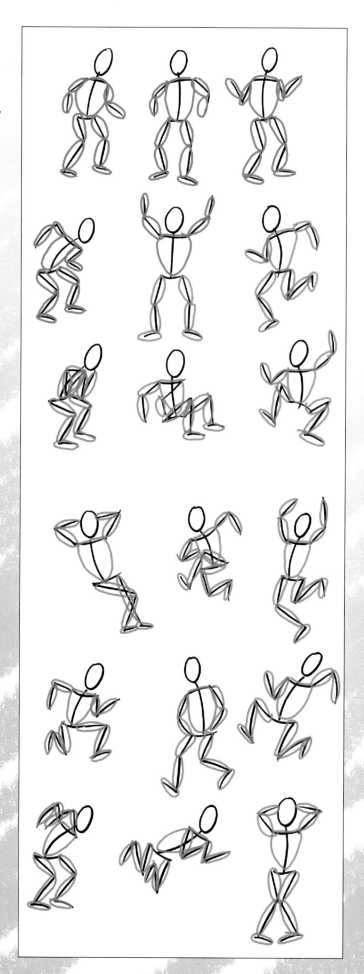

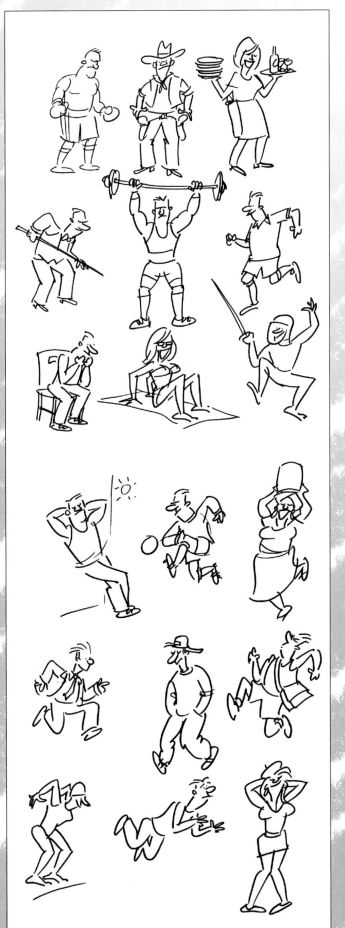

FLESHING OUT

It is now time to switch from a pencil to pen and ink or whatever you prefer to use for drawing finished cartoons.

Using the body shapes you have created as a guide, draw a selection of real cartoon characters. At this stage don't worry about too much detail, faces etc., just enjoy experimenting.

Because of all the preliminary roughing out you have done, you know already where everything is going to go and drawing the characters has become a lot easier than drawing them straight off onto a blank sheet of paper.

ANIMALS: THERE ARE A LOT OF THEM ABOUT...

...and if you're drawing cartoons, they are difficult to avoid. So, having got to grips with the basics of drawing the cartoon human, let's apply similar principles to drawing cartoon animals. Rather than start with a stick animal, it is easier to combine the stick and the balloon approach and think in terms of geometric shapes.

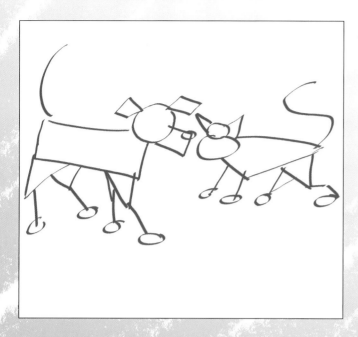

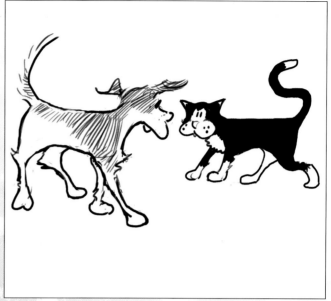

▲ Find a picture of the animal you want to draw – or use the family pet as a model. Look at it carefully and you will see how easily the body shape can be broken down into ovals, circles, squares, rectangles, triangles, etc.

LET'S GO ANTHROPOMORPHIC!

Of course, a lot of cartoon animals are a mixture of real animals and humans – in other words, anthropomorphic. In fact when many people think of cartoons, the first image that comes to mind is often that of an animal behaving like a human.

There is, however, a lot more to drawing this kind of animal than simply putting a dog's head on a human body, carrying a briefcase and wearing a nice suit, hat and shoes.

When you set about drawing an animal with human attributes, try to find those parts that can be adapted from one to the other. For instance, the feathers on a bird's wing-tip are ideal for turning into fingers.

A final word (for the moment) on anthropomorphism: when you create one of these characters, choose the right animal for the job. What you are looking for could be in the face (expression, eyes, etc.), in the way the animal stands or simply its personality.

Of course, as a cartoonist, you will be aware that a sense of the ridiculous can give your work impact too, so you could choose an animal that has exactly the opposite attributes to those that might be expected. Below are some examples, including two of the latter.

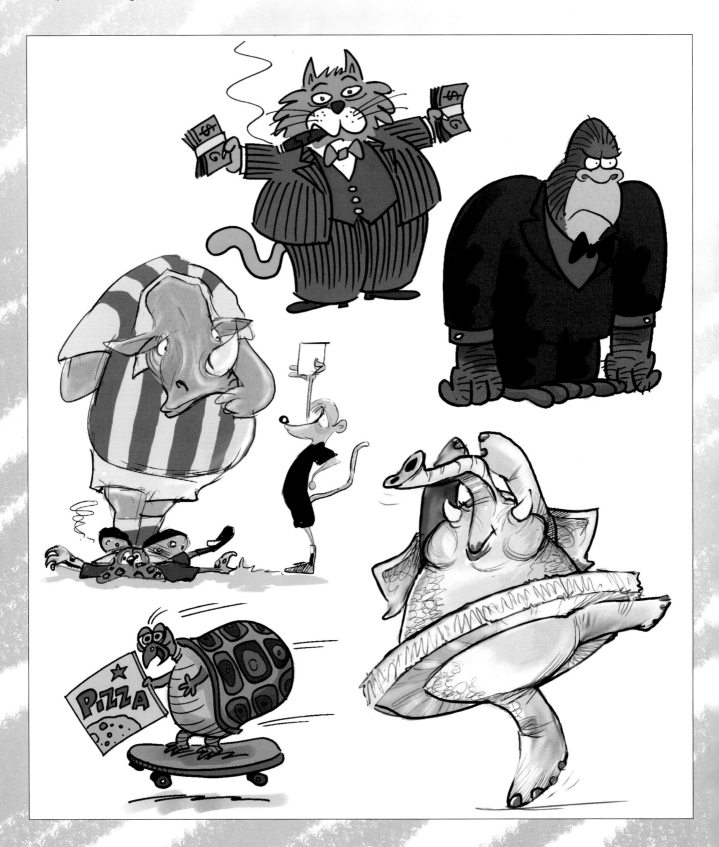

THE FINER DETAILS – FACIAL EXPRESSION

After that brief excursion into the animal kingdom, we return to our human cartoon characters. So far we have looked at the character as a whole, but in a very loose way. The next step takes us into adding detail to the characters, in particular, faces.

Faces are a key element in establishing your character's personality. The ability to convey the state of mind of your cartoon characters through facial expression is one of the most important cartooning skills you need to master.

If you are to become proficient in this skill, it will be helpful if you have an expert on hand as you work, with whom you can consult. Fortunately, we can provide one for you at no cost whatsoever, providing you have a small mirror, because the expert we are talking about is you!

So, if you can find a small mirror (large enough to show all of your face), use it to compare your own expressions with the examples that we will be showing you, and also to assist you when you are drawing.

As with our stickpeople, we need to start with the basics. Facial expression is a language which we use to communicate non-verbal emotions – feelings, moods, etc. It is actually part of what we call body language and, as with any new language, we start with a few simple phrases or, in this case, expressions.

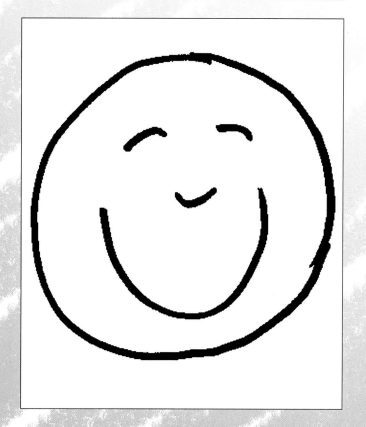

Most people are familiar with, and can draw, the classic smiling face. This is easily recognized as the standard expression for happiness. It is extremely simple, comprising only five lines and yet it conveys, very strongly, the desired emotion. This is, of course, the very essence of good cartooning.

Even so, it is a little too simplistic for most purposes so let's take it a tiny bit further.

HAPPINESS IS OVAL-SHAPED!

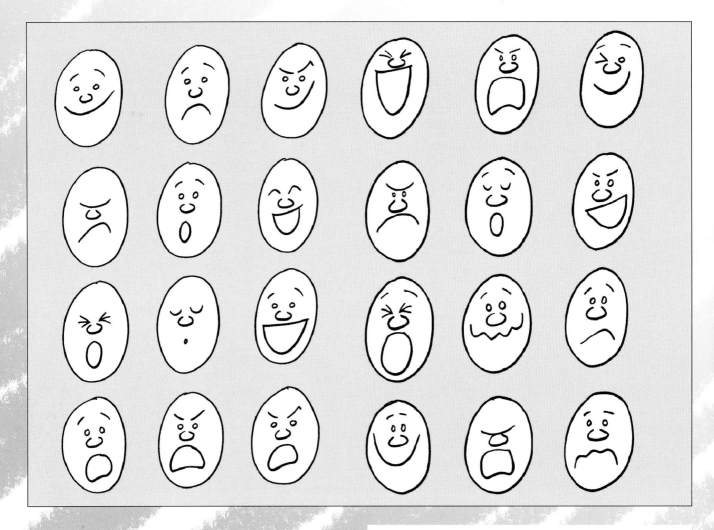

Here are a few more basic faces, based on a simple oval shape. It's a good idea to draw a page of empty ovals, make a few copies and then use them to practise drawing these expressions and any others that come to mind. At this stage we won't go into any explanations. This is, as we said, a new language and the first steps in a new language are mainly repeating what we hear. So just have some fun working with these simple shapes whilst at the same time getting a feel for how much information a few basic lines can convey.

Top Tip

We wouldn't suggest buying a computer webcam just for this purpose, but if you already have one, it is even better than a mirror because you can capture images of your own expressions and build up a very useful reference library.

Now let's get a little more complex and examine what happens to the face when we change our expression. Look at the examples above. Each stage is represented by two drawings, the one on the right being much simpler than the one on the left, but the rules are the same for each.

Notice that, as the expression develops, other parts of the face come into play. See how the wider the smile becomes, the more the eyes appear to close. This is because the muscles on the cheeks are forced up and outwards. Try it yourself with the mirror.

Notice also how the other elements develop as the expression becomes more extreme. The head changes position, which in turn influences other things. Nothing happens in isolation.

Remember that you can increase the impact of your cartoons with skillful use of the right expressions; the double take, the contented smile, the gesture of surprise or smugness, anger, laughter, doubt, looking aghast. These and many more each have their own unique and cartoonable expression which, combined with the correct body posture, will make your cartoons very effective indeed.

Cartoonists are people watchers. Start to observe how people react in conversations, and make good use of that mirror.

At this point, think of as many emotions and moods as you can and see how well you are able to convey them in your cartoon faces. Here are twelve to start you off. Once again, notice how every part of the face comes into play, including the hair.

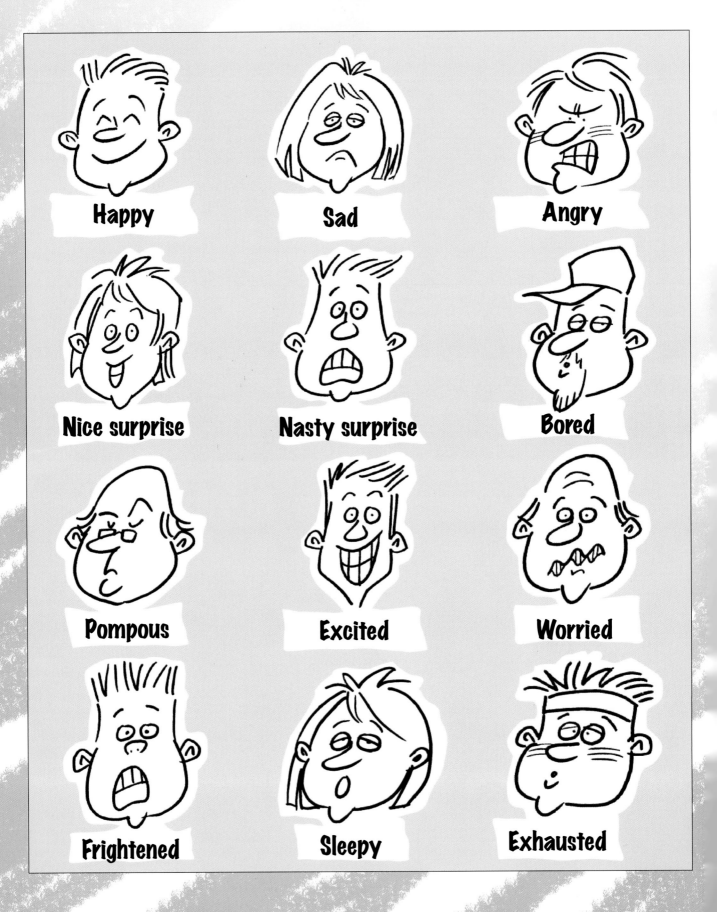

Happy

Sad

Angry

Nice surprise

Nasty surprise

Bored

Pompous

Excited

Worried

Frightened

Sleepy

Exhausted

TOO MUCH INFORMATION!

Before we move on and think about attaching heads to bodies, we should mention one of the most common mistakes that newcomers to cartooning make. Because things like eyes and ears are quite complex things to draw, it is very easy to get bogged down in detail and forget one of the most important rules of cartooning – which is to keep things simple.

▶ Whether your style turns out to be very loose or quite intricate, the keynote should still be simplicity. Look back at our examples and you will see what we mean. The eyes in particular, along with the eyebrows, are very important features, and the viewer's own eyes are immediately drawn to them. As with many aspects of cartooning, less is often best and you should really try not to overwork them.

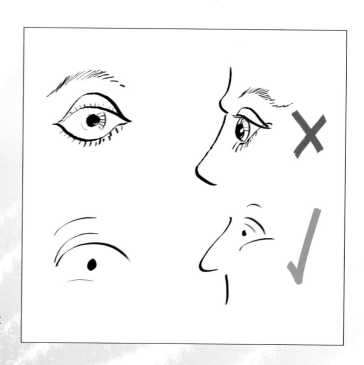

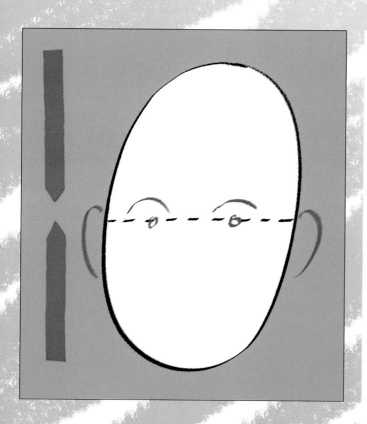

▲ Finally on the subject of eyes and ears, remember that they are situated at around the halfway point of the face.

Top Tip

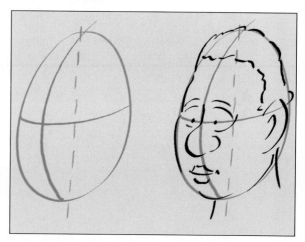

Cartoon characters look a lot more interesting when seen from a three-quarter viewpoint. It's not a difficult thing to master but to make sure things go in the right place, rough out your face, in pencil, like this.

BODY LANGUAGE

It's a language that, in real life, can express our feelings, our attitudes, our opinions, all without us having to open our mouths to speak a single word. Body language is a language without words but with a huge vocabulary.

The position of figures in a cartoon and their relative attitude to each other is mostly expressed through an understanding of body language. Style will vary enormously from cartoonist to cartoonist, but posture is the great constant that will relate to everything we produce.

Let's begin with the standing figure. As an observant person you will naturally be aware of the fact that people spend most of their time standing on one leg...well, alright, let's rephrase that! People are mostly either right- or left-handed but, equally, they are right- or left-sided. The natural way to stand is with your hips positioning one leg almost vertically under the bulk of your body mass with your second leg being used as a counterbalance.

▶ Look at these two illustrations. The top one shows the way most beginners would tackle drawing a typical standing figure, whilst the bottom shows the same figure standing in a much more natural way.

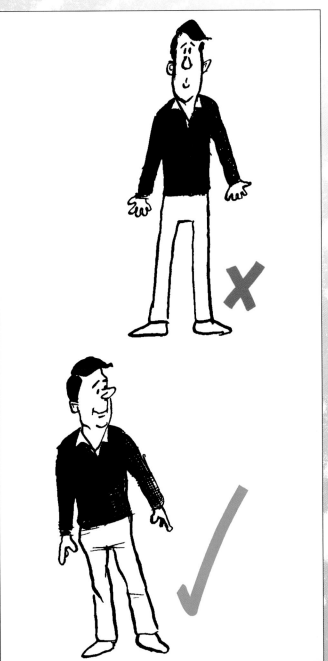

PEOPLE-WATCHING ▶

You should make a point of taking up the exact posture of any figure you want to draw and feel the natural balance, where the weight falls, etc. If you have a full-length mirror, use that.

Alternatively, go out in the street and do some people-watching. People-watching is something that cartoonists do naturally, wherever they are – in town, at the station, in restaurants and bars, at spectator events, wherever there are people to watch in fact! A lot of what you observe will be retained in the subconscious, ready to pop into your mind when you are staring at a blank piece of paper – you hope!

It's better really to go prepared and carry a small notebook and pen with you. Of course, you could also put that camera that you never use on your mobile phone to good use too!

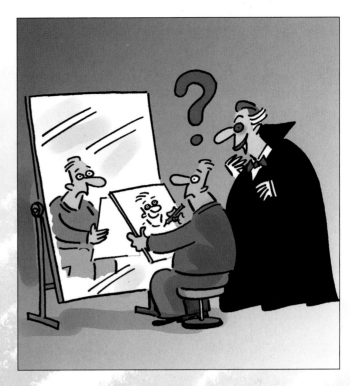

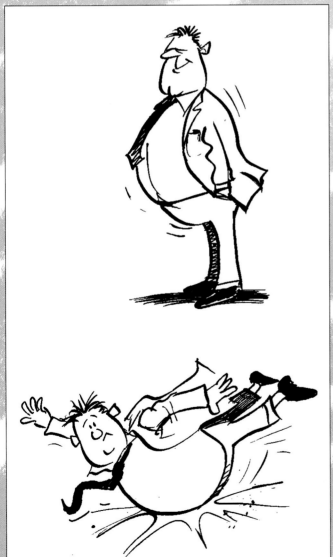

◀ BALANCE

A key element of posture is balance. Here, we are talking in the literal sense. If you draw a stationary figure that is unbalanced, the eye of the viewer will immediately be aware of it and it will diminish and detract from the point of your cartoon. Using the figure of a, well, let's say gravitationally-challenged man as an example, we can see that drawn simply in profile, if no account is taken of the large stomach – he falls over.

Here are four illustrations showing different ways in which a figure can be made to look balanced.

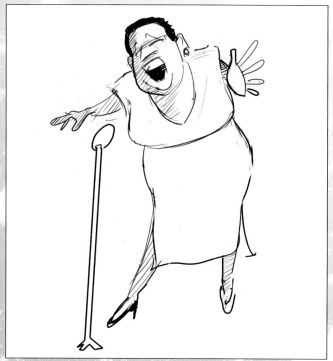

1 – one leg is used as a counterbalance.

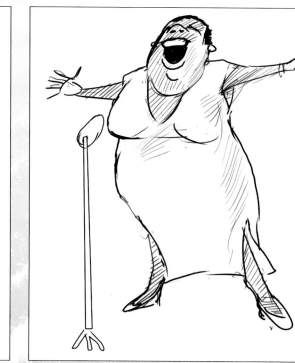

2 – she simply leans backwards.

3 – a balancing aid is used here...

4 – and here.

See if you can think of other ways in which this balancing act can be achieved.

We have said that posture is an excellent indicator of mood. On page 34 we demonstrated the way in which mood and emotion can be shown in the drawing of the face but, as you can see from the examples below, those same feelings can be expressed, to a degree, using body posture alone.

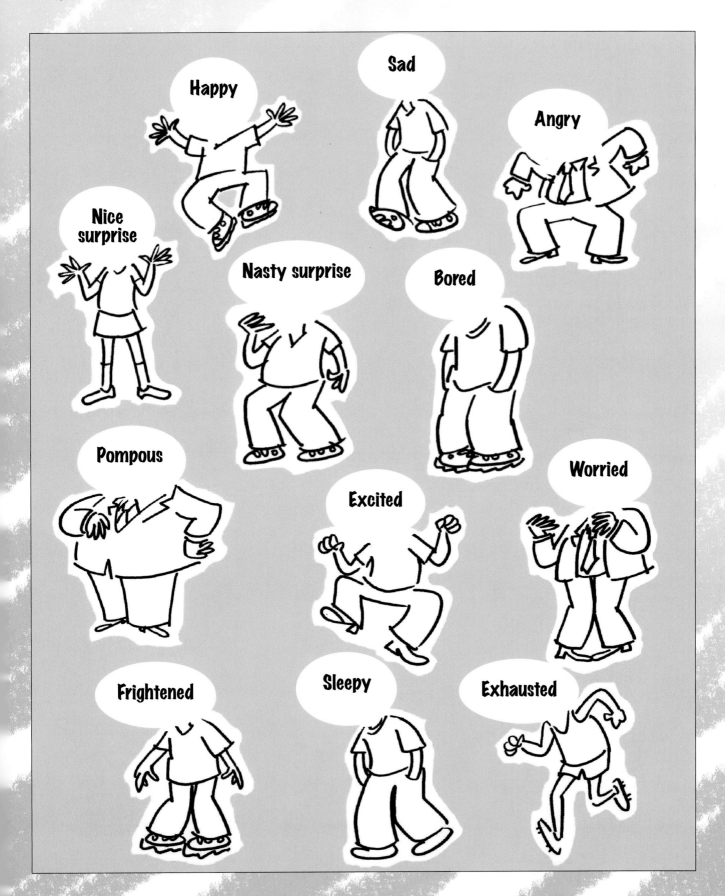

PUTTING IT ALL TOGETHER

When looking at the headless cartoons (see page 39) you probably noticed that some worked better than others. That's okay, because it is highly unlikely that you will need to rely on body language alone. Add the heads to the bodies and you'll really be getting somewhere! Let's take a closer look at the various elements that we have combined to such expressive effect.

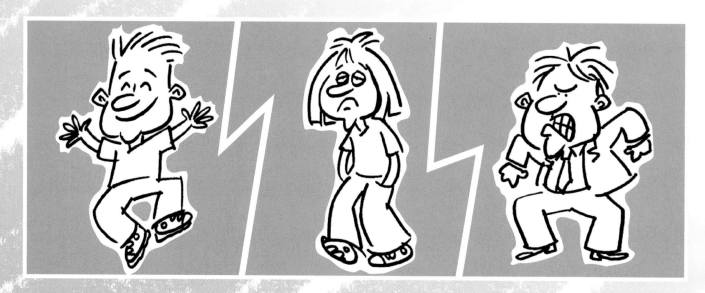

HAPPY The hair mimics the hand gestures. The eyes are closed, drawn simply as two arcs. The feet are free of the ground.

SAD Shoulders slumped. Round eyes bisected with eyeballs half covered. The hair follows the line of the shoulders, emphasizing the slump.

ANGRY This figure is all sharp angles. The single eyebrow over two small dots for eyes is a very powerful image for so few lines.

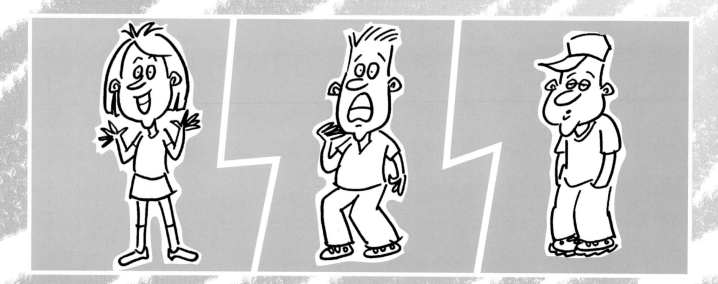

NICE SURPRISE Similar to the happy chap but eyes (and mouth) wide open.

NASTY SURPRISE Wide eyes, straight eyebrows. Hand to downturned, open mouth. He has stopped in his tracks.

BORED Slumped shoulders, hands in pockets. Similar eyes to the "sad" character but the mouth changes everything.

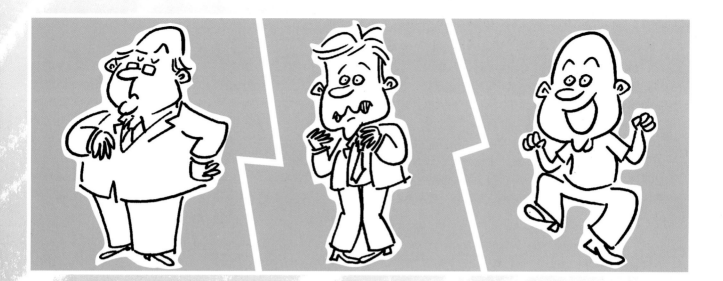

POMPOUS The eyes here are similar to the "happy" eyes but drawn the other way up. The thrust-out chest and the arms demonstrate two classic positions for this type of character.

WORRIED The twisted mouth is yet another classic, along with the inward turned feet. The twitching hands complete the picture.

EXCITED Similar to "happy" except the eyes and mouth are open. The clenched fists add the tension of excitement (similar to the "angry" character but in that case it was a different kind of tension).

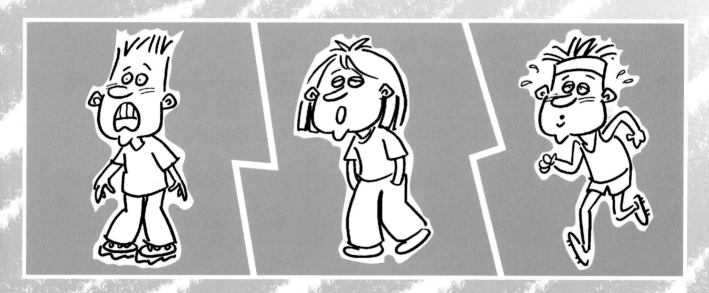

FRIGHTENED Hair literally raised and the limbs are clearly out of touch with central control! Inward turned feet depict either uncertainty or, as here, lack of control over the body.

SLEEPY It's unusual to show a sleepy character walking and in this case most of the work is done with the eyes and mouth.

EXHAUSTED Note how similar the mouth is to the "bored" character, yet used to such different effect when combined with hot cheeks (depicted with just a couple of lines) and the sweat effect.

Quite a few of the same features can be combined with others to give a different effect. If you were able to come up with some of your own ideas for faces expressing feelings, have a go at adding bodies to them with the appropriate posture. You will see just how dynamic your cartoon can be.

STYLE

This is probably as good a time as any to mention style. Would-be cartoonists (and some of the old hands too!) can often be heard complaining that they aren't happy with their style and that they are trying to find the right one. The truth is that it's style that finds the cartoonist and, whether you like it or not, that is the way you will naturally draw. Some of us draw so tightly that you'd think a ruler had been used, while others will be so loose that the cartoon looks in danger of falling apart.

The majority of cartoonists, of course, fall somewhere between these extremes. It's important to remember however, that whatever your style the basic rules apply. For the body language examples (see pages 39–41) we used the work of one cartoonist, mainly because of the clarity and simplicity of his line work. Had we used another style, however, all of the points made would have been exactly the same, albeit with a few embellishments typical of the new style.

▼ Look at these two examples. The styles are completely different but the basic pattern is identical.

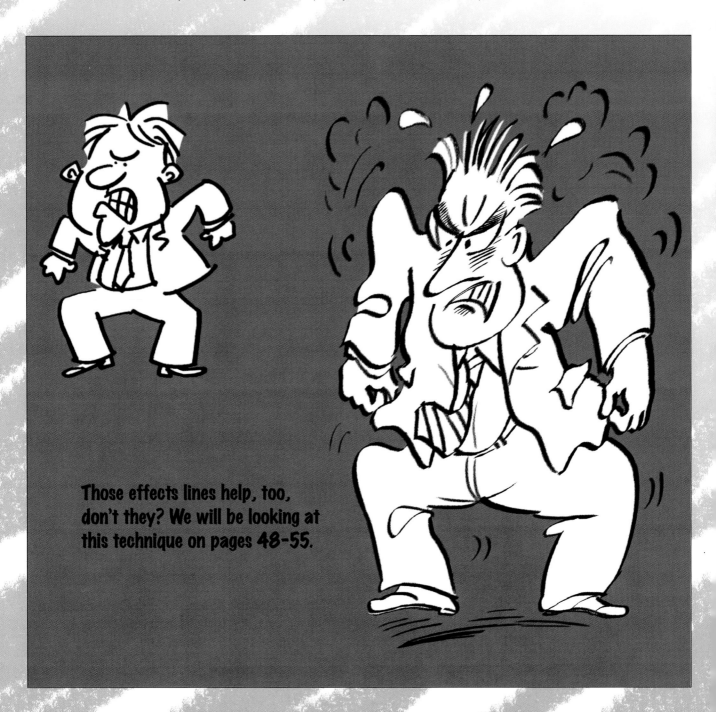

Those effects lines help, too, don't they? We will be looking at this technique on pages 48-55.

ARE WE GOING TO STAND AROUND HERE ALL DAY?

▼ So far, like the character shown here, all of our cartoon folk have been quite static and it's time they started moving.

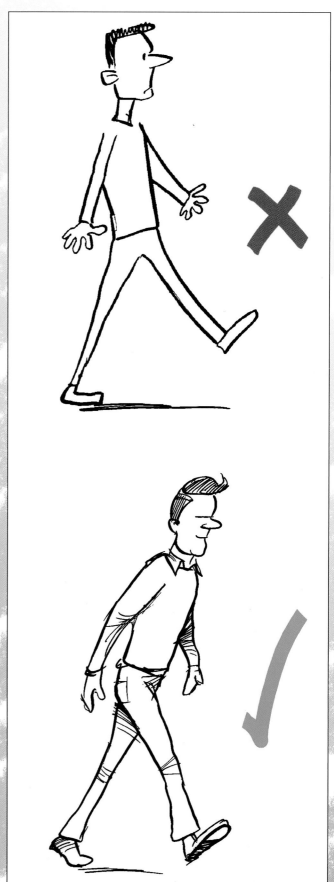

▶ We've learnt the importance of balance and counterbalance and these principles apply equally to movement. Again, we'll start with a typical beginner's walking figure.

If the first standing figure on page 36 looks as if he'd be more at home standing to attention on a military parade ground then the top figure here looks as though he has been given his marching orders! Every part of the body is far too rigid, and people simply don't move like that.

The bottom figure however, shows a more typical poise. Note how the feet bend to fulfill their role as a springboard to launch the body forward. Notice also how the hands are relaxed since they have no part to play. (More on hands on pages 46–47).

It's interesting – and important – to understand that walking and running are, in simple terms, a continual process of falling over. You lift your foot and fall forward, bringing the other foot forward to stop yourself from falling. This process is repeated and you move forward.

▶ When you draw a walking or running cartoon figure he should be equally unbalanced – bending slightly into the direction of movement and bringing forward the non-weightbearing leg.

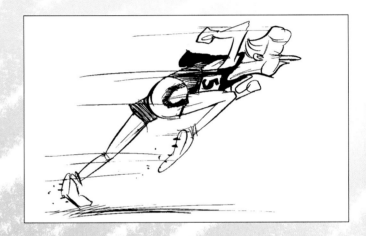

▶ If you want to convey the figure moving rapidly, increase the angle and exaggerate the action of the legs. As you can see, whereas balance is important to static cartoon characters, lack of it is important to moving ones.

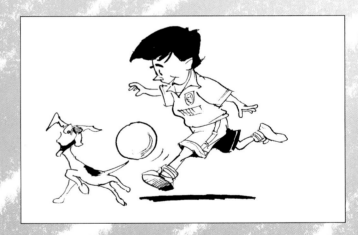

Finally let's look at how posture changes with age. The cartoon will exaggerate and emphasize these differences to convey quickly to the reader the scene the cartoonist has in mind.

▶ Young children, it seems, are permanently off balance. Their centre of gravity is so low they almost seem to bounce along and it's a good idea to draw them as such.

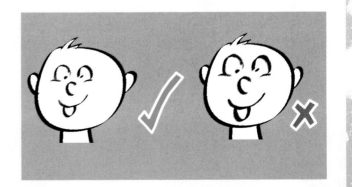

Top Tip

A child is not a miniature grown-up. The head of a child is much larger in proportion to the body than is the case in an adult. Also note that the features of a child should be drawn smaller in proportion to the size of the head.

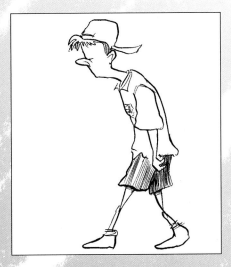

Teenagers have a gangling awkwardness. Because their bodies have stretched upwards it throws their natural equilibrium out of balance, which they haven't yet learnt to control. Try drawing them without the poise that adulthood brings.

Posture then tends to decline with age. This could be as a result of weight gain, illness or frailty.

Many older people require some form of help to balance, such as a walking stick.

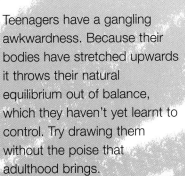

◄ Don't fall into the trap of drawing stereotypes. Older people (and would-be cartoonists who fall into this category will know what we mean!) don't always act their age, as the lady in this cartoon shows!

Similarly if you want to reflect the real world in what you draw, you shouldn't produce a series of automatons of equal height, age and features. If you learn to convey body language by means of poise and disposition, you will be well on the way to producing cartoons that people can relate to.

HANDS

The hands are an important part of posture and body language. It's a fact that most people simply tag them onto the ends of the arms without giving any thought to the position that will best serve the overall impression they are trying to create.

Earlier, we learned the importance of the correct use of facial expression. However, a simple gesture with a hand to attract the eye of the viewer to a particular part of the cartoon, or to emphasize the state of mind of a figure, can convey exactly the same information. The skilled combination of both will do wonders for your work.

▼ It is generally agreed that hands are the most difficult part of the body to draw. This artwork shows the basic parts of the hand. Think in terms of the hand being made up of three parts: wrist, palm, then the fingers and thumbs.

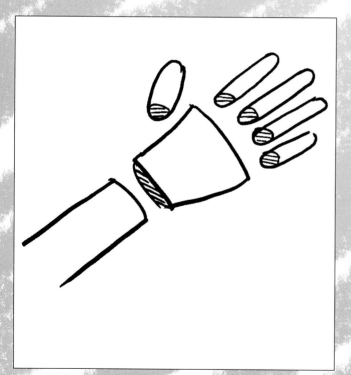

▼ This is the wrong way to draw hands. This is an extreme example but it demonstrates the basic mistake many people make. By having the fingers attached directly to the arms you have no room for flexibility – which in turn will give your figures the rigidity of a scarecrow.

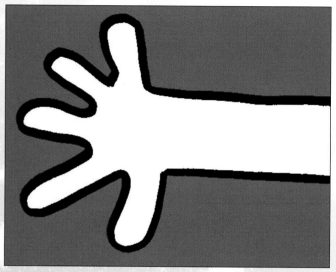

▼ Make a point of drawing the palm first. When you join it to the wrist it becomes extremely flexible and can move in a separate direction entirely from the digits that you add last.

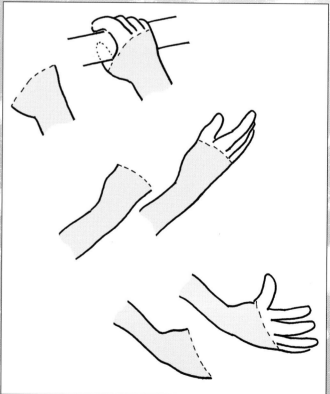

In many aspects of cartooning, you learn a lot from practising the correct way to draw something. Having learned the basic rules however, as a cartoonist, you are allowed to bend them up to a point.

As with eyes, one of the common problems cartoonists have with hands is that of getting bogged down in detail. There is something about all those fingers that make you tense up and start to draw rigidly as you concentrate on trying to get it all right.

Top Tip

▼ The secret of drawing good cartoon hands is to be more stylized and less intense. Sometimes, for instance, drawing all four fingers can make a cartoon hand look overcrowded and many cartoonists draw only three fingers.

If you really have difficulty drawing hands, you can hide them in pockets, behind backs, etc. Don't overdo it though – you have to get to grips with hands eventually!

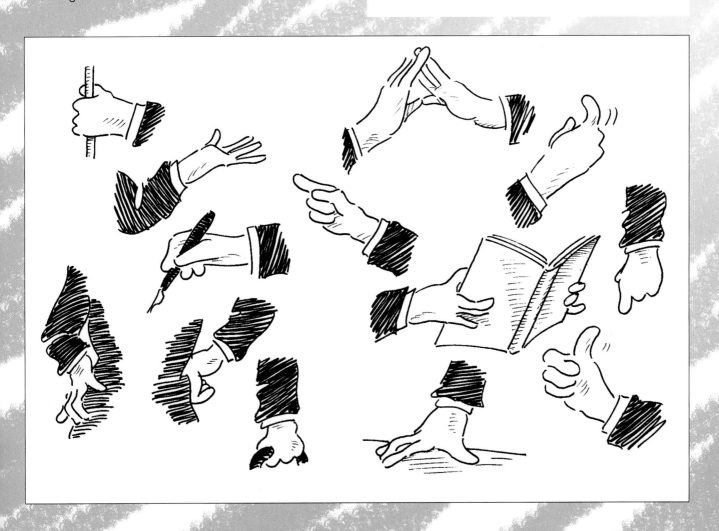

MOVEMENT: Bringing your Cartoon to Life

Movement can be an important element in a cartoon. It creates interest and it catches the viewer's eye, drawing it into the cartoon. It can even be used to manipulate viewers, making them see elements of the cartoon in the right order, much as a stand-up comic will use timing to lead the audience into the punchline of the joke.

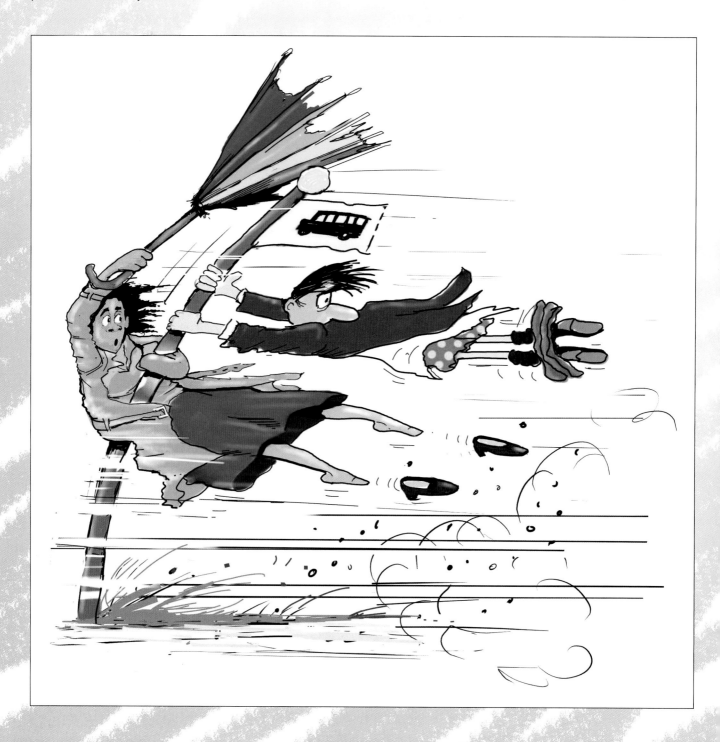

Mostly, though, movement in a cartoon is just… movement! The cartoon shown on page 48 uses almost every movement trick in the cartoonist's book.

• Speed lines: these show the main direction of movement. It is important that these lines run parallel to each other – if they don't, a lot of the effect is lost.

• Dust clouds: used with speed lines, these give an impression of turbulent motion.

• The cartoon elements: drawn so that they add to the movement effect. The two characters are being pulled in the direction of the movement, especially their hair, and items of clothing are detaching and being pulled in the same direction. The bus stop is bending and the umbrella is being sucked inside-out, all in the direction of motion. The sense of movement in this cartoon is so strong that we just know that if either of those characters loses their grip they will disappear right off the page!

The example we've just been looking at is very effective in terms of showing movement, but you're not quite at that stage yet. Let's start from the beginning. Most of the time you will want to show movement in a simpler format, perhaps related to just one character or object in your cartoon.

▼ In these examples, with the help of our old friend the stickperson, we will keep the drawing to a bare minimum in order to emphasize the techniques.

Compare the figures on the left with those on the right and see how much difference just a few movement effects can make.

In the top right example, speed lines have been used in conjunction with other movement lines that suggest the blur of movement as the arms swing and the head moves.

In the bottom right example, the pace increases and more lines are added behind the head and dust clouds are used to indicate high speed.

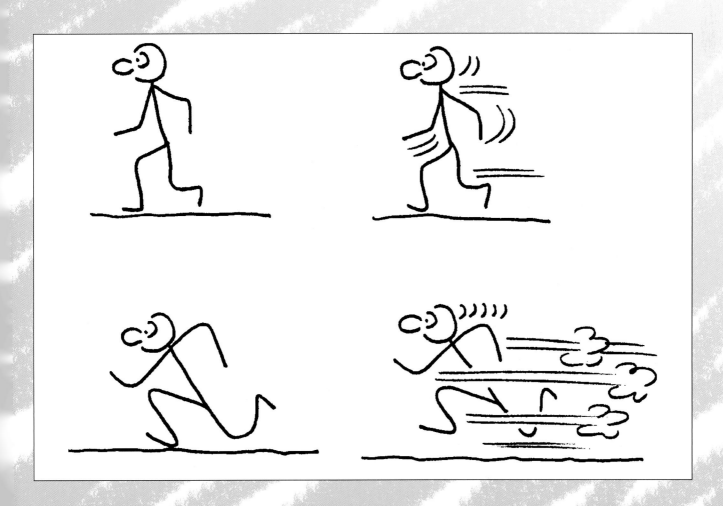

▶ Movement doesn't necessarily have to be linear of course. In this example although the character is walking, we are more concerned with the head movement. By omitting all movement lines apart from those around the head, the effect of the "double-take" is very much emphasized.

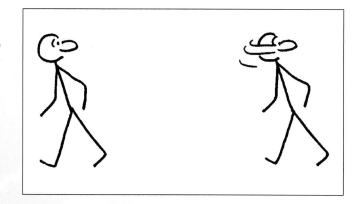

▶ In this example the movement effects are used mainly to depict emotion and the state of mind of the character.

▶ Hair movement, multiple movement lines and "rage" clouds clearly define the state of mind of this character.

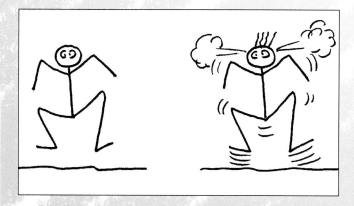

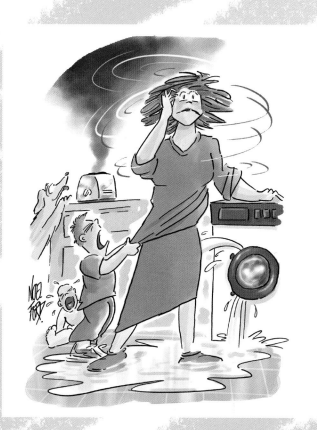

◀ This cartoon includes many of the movement line examples that we've just been looking at. They help to clearly show the state of mind of the character.

MOVEMENT LINES ARE USED...

... to indicate rapid and repetitive action.

... in conjunction with sweat beads to indicate exertion.

...with the drawing of multiple arms and eyes etc. to indicate spinning.

... on the character's hair and clothing. In this example, paradoxically, the thing that is moving is the air, which we can't, of course, see. The movement lines and other effects in this case really show that the character is fixed to the spot.

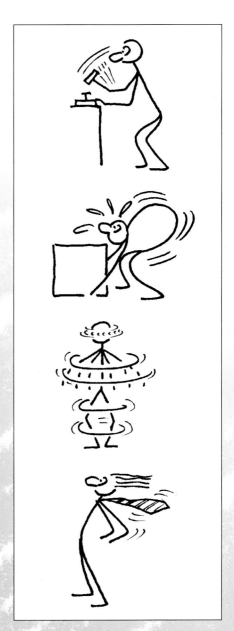

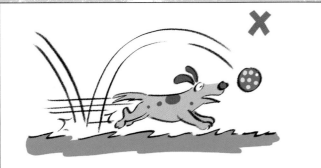

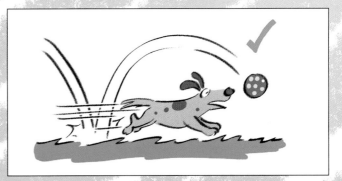

▲ Never use more movement lines than are necessary to create the desired effect, otherwise the cartoon may become a confusion of lines. If you have two things moving in different directions and you have movement lines crossing each other, break the lines at the crossing-point. The example above shows the wrong and right way to use movement lines.

SWINGING

Look at the illustration on the left and then the one on the right. Notice how just two sweeping lines really swing the axe whilst at the same time the flying splinters of wood stop it dead in its tracks. So much information is conveyed in just a few lines. See also how the movement is enhanced by leaving the space between the two lines empty where the sweep of the axe passes in front of the character's legs.

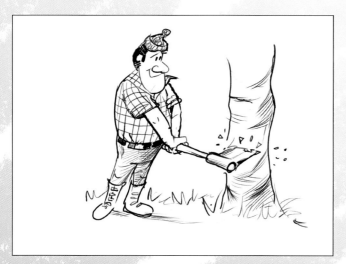 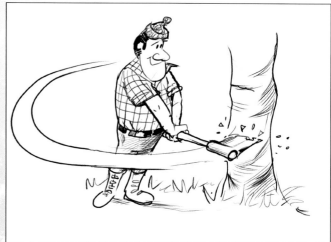

DROPPING

What is wrong with the falling weight on the left? Answer – the movement lines are fine but the weight looks as though it has been glued to the ground! To achieve the desired effect we have to show not only the speed of the falling weight but also the heavy impact as it hits the ground. The latter is accomplished with that "splat!" effect and the surrounding dust clouds.

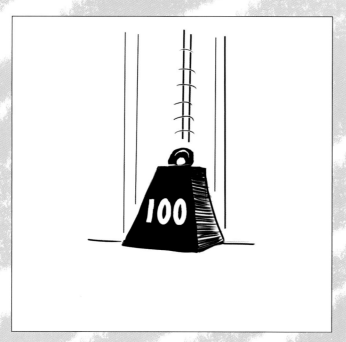 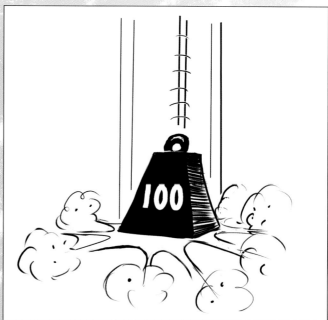

PUSHING

Again, in this cartoon, movement lines are not enough to show all the effort that the character is putting into moving that crate, but the sweat beads and the clenched teeth complete the effect. Try not to think of an effect in isolation. Always imagine what other effects might be brought into play by the particular action that you are drawing.

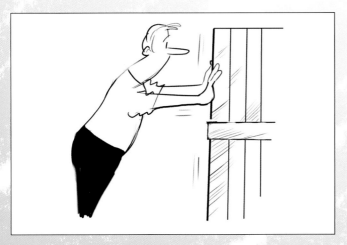
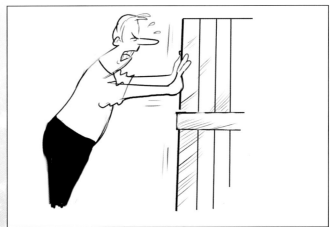

REBOUNDING ▶

Look at these two examples. The first cartoon captures the moment when the clock hits the cat. The second cartoon shows the clock rebounding off the cat. A thrown object always looks much more effective when it bounces off its target. Cartoon sound-effect words such as "thunk!" are a useful device too, although you should be careful not to overuse them.

The authors would like to point out that no animals were harmed in the drawing of this cartoon!

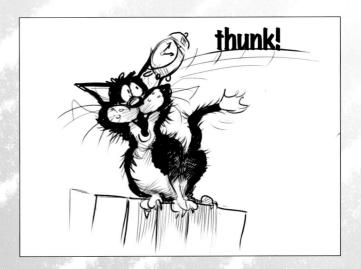
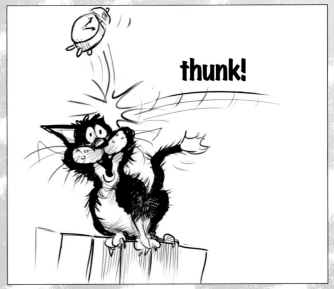

EFFECTS IN THE PUBLIC DOMAIN

Here is a selection of special effects which convey instantly to the viewer a complete picture of what is going on – gloom and doom, a headache, love, inebriation, pain. The list is endless – literally.

It is endless because cartoon effects, like facial and bodily expression, are a language – a living language that is being added to all the time. All of these effects are in what is called "the public domain". Obviously someone, somewhere, must have been the first to draw each of the effects we see in daily cartoon use but we either don't have a clue who it was or more than one cartoonist claims it as his or her own!

Anything in the public domain is available for anyone to use, without any fear of breaching copyright, and so you will see exactly the same effects used by many different cartoonists. Who knows? As you draw you might come up with a new cartoon effect that, in years to come, all cartoonists will be using!

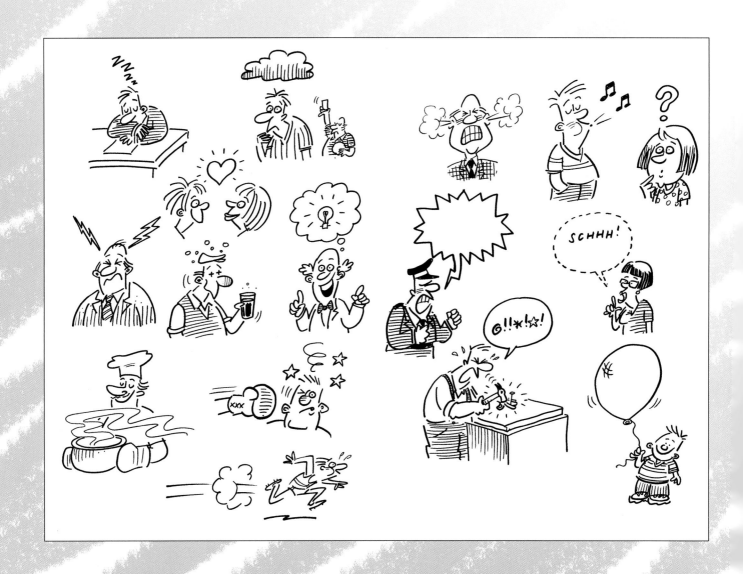

When is a movement line not a movement line?

▶ In the first cartoon, the character is obviously finding it difficult to stay on her feet, but why? In the second cartoon the explanation is clear – she is walking on ice. This information is conveyed with just a few vertical strokes of the pen; what appear to be movement lines are actually doing another job entirely.

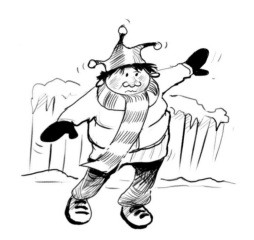

▼ It's a very useful technique, not only for ice, but for any shiny or polished surface – a mirror for example.

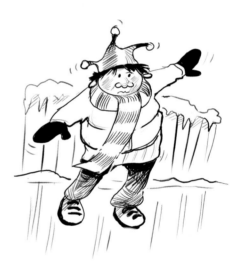

STOP IT!

Believe it or not, one of the hardest things in cartooning is not getting started, but knowing when to stop. This is particularly true when drawing movement lines – it is always very tempting to draw just one more and then another. Before you know it your cartoon is a jumbled mess. The answer is either to have someone watching over your shoulder all the time, ready to snatch the paper away from you the second they think the cartoon is finished; or, more practically, to try to discipline yourself to stop before the drawing is spoiled. This is something that you will have better judgement on as you become more experienced.

ADVANCED TECHNIQUES

In this section we'll look at the various ways in which shade, tone and colour can be applied to make your cartoons more interesting.

So far, we have concentrated on basic line artwork. This simple style of cartooning can look very good without any embellishment, and many cartoonists prefer this uncomplicated format. Even so, there are a number of shading and toning techniques that, if used with care, can literally add another dimension to your cartoons.

The first thing these techniques can offer is that literal extra dimension. A simple line drawing will tend to look quite flat – two dimensional in fact – but shade and tone, when skillfully applied, can give it that extra, third dimension, creating the illusion of depth. This will automatically make your cartoon more interesting and eye-catching because depth draws the viewer's eye into a drawing and makes it less likely that it will be skipped over or ignored. Cartoonists don't mind so much if their work isn't liked but they hate it to be ignored!

▲ In this example the cartoon looks very flat on the page.

◄ Look at the difference in this illustration. The use of simple line shading, or hatching, helps to lift it, creating the illusion of three dimensions.

It isn't only depth and dimension that shading can add to your cartoons; it can also be used, in a dramatic way, to create atmosphere and motion, as the cartoons on page 57 demonstrate.

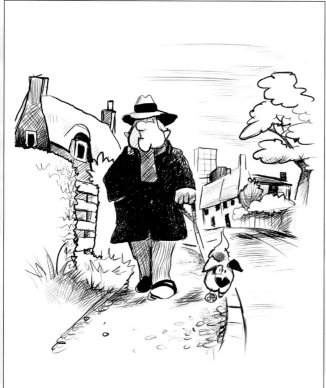

► The hatching in this cartoon has been used dramatically to produce both a scary atmosphere and the sense of movement. See how the swirling shading around the light not only seems to make it shine but also move. Notice also that the shadow of the cleaning lady is not simply there as decoration – it is integral to the meaning of the cartoon.

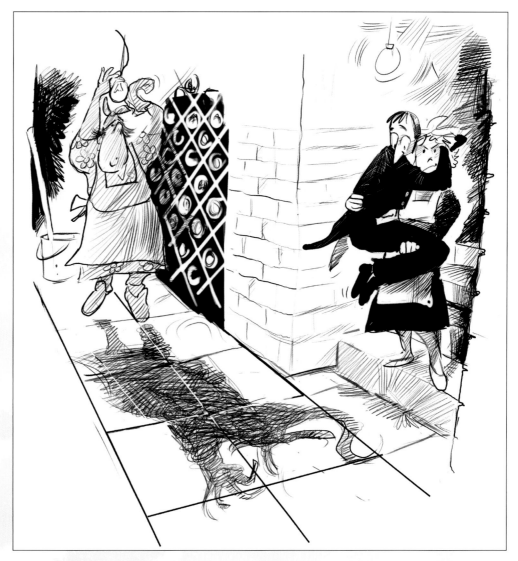

◄ Similarly, in this example the sense of atmosphere and movement has been enhanced with a form of shading. In this case however, instead of hatching a "wash" has been used.

WHERE IS THAT LIGHT COMING FROM?

Before we start looking at how and when to use shade and tone we need to remind ourselves of the way light affects subject matter, creating shade and tone in real life.

All objects create their own shadow and it is a good idea to take into account the direction from which light is coming when you are about to shade. You don't necessarily have to draw the actual shadow (although sometimes it is necessary, as in the example on page 57), since this could complicate your cartoon unnecessarily. However, by deciding on the direction of the light you can make sure that your shading is consistent. If you draw hard shadow on different sides of various objects within a cartoon it will usually look wrong. Therefore, decide where your light source is; the side on which you would normally see a shadow on your subject is the side to apply your shading. On the opposite side to that shading you will need nothing or only light shading.

▼ Look at the two examples below. In the first one, light seems to be coming from all directions at once and it actually makes the drawing uncomfortable to look at. In the second one, light is coming from a single direction and everything looks much better.

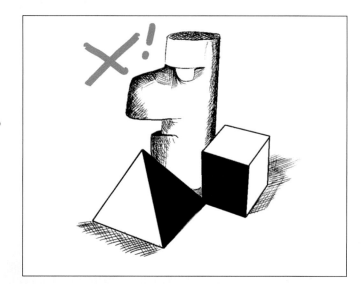

Top Tip

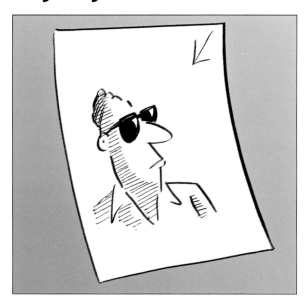

If your cartoon includes the main light source, such as the sun or an electric light, this in itself will act as a reminder for where any shade should lie. If the light source is not included in the cartoon you may find it helpful to lightly pencil in an arrow showing the direction of the light.

Of course it is possible that the light could be coming from the centre of your cartoon, from a lamp for instance. In this case the shading would depend upon which side the objects or characters were standing.

HATCHING AND TONING

Now that we know roughly where to put our shading, we need to decide which shading technique will suit our work best. We are going to take a single cartoon and see how different styles of hatching and toning can affect it.

Here is the cartoon without any shading at all. You could photocopy this or scan it into a computer and print off copies that you can use to practise the different techniques described on pages 60–63. Of course, you may prefer to draw your own cartoon and make copies to practise on. Keep your cartoon fairly simple, similar to this example.

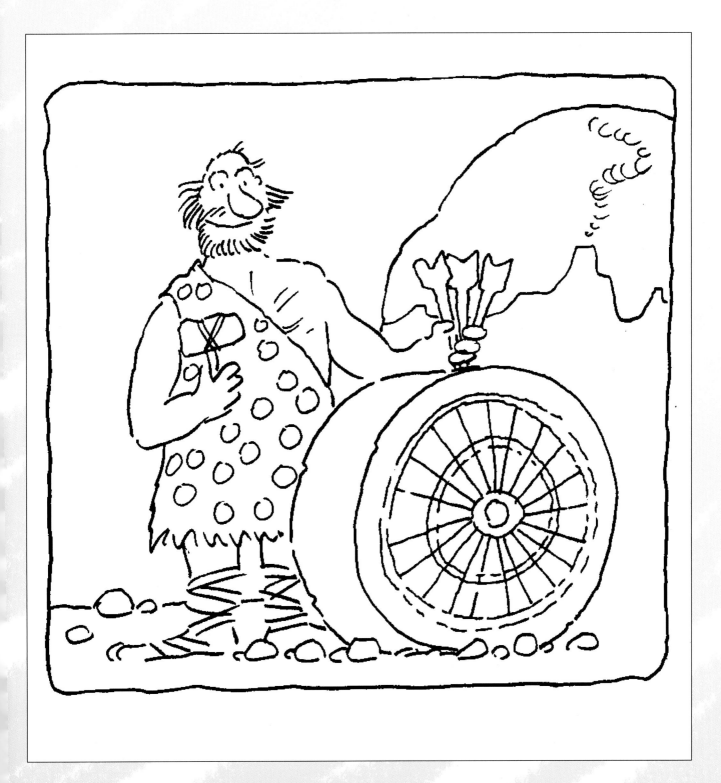

HATCHING ▶

Hatching is the use of short straight lines, arranged in small blocks that are positioned at angles to each other, rather like square bricks in a very higgledy-piggledy wall. This form of shading is good for flat areas of tone, though you can create some variation by using different thicknesses of line.

Thinning the lines and increasing the distance between them, as shown in this example, allows you to fade out your shading instead of it stopping abruptly with a hard edge.

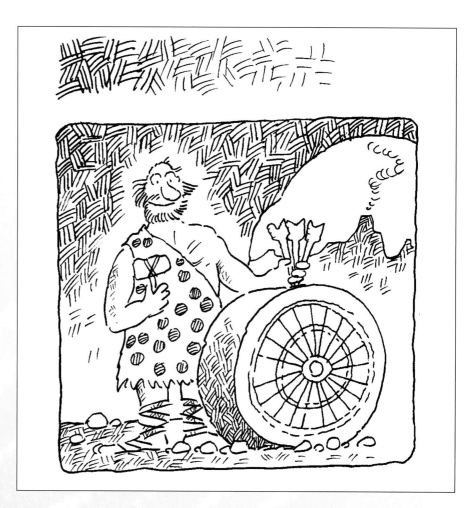

◀ CROSS-HATCHING

Cross-hatching is the use of parallel strokes, overlapping each other at various angles. The degree of darkness and lightness is controlled by the thickness of the lines, how close together they are, the angle at which they overlap and how many of them overlap each other.

Cross-hatching is good for large, fairly tightly drawn cartoons where you want to create a lot of variation between light and dark.

RANDOM HATCHING ▶

Random hatching is, as the name implies, a completely random pattern of lines – in effect, a controlled form of scribbling. Light and dark is achieved in the same way as in cross-hatching.

Random hatching is very effective for more loosely drawn cartoons, but be careful! It is very easy to overdo all forms of hatching but this is especially true for random hatching. In the blink of an eye a nicely toned cartoon can be transformed into a dark and indecipherable muddy mess!

◀ LINE HATCHING

Line hatching comprises lines running roughly parallel to each other. They can be straight or follow a curved surface. Light and dark is controlled by line thickness and by how close the lines are to each other.

Line hatching is suitable for most styles of cartoon, but it does have another very useful attribute. With practise, you can use the combination of line thickness and curvature to create very realistic three-dimensional effects, as shown in this example.

HALFTONE

Halftone, or mechanical tint, is a series of dots arranged in parallel lines. Originally a photographic technique, cartoonists have used it for many years. The effect is a flat tone, varied by using different size dots and increasing or decreasing the size of the space between them.

For a long time, mechanical tints were applied using special sheets of halftone dots with an adhesive backing, which could be cut out to the right shape and stuck to the artwork. Nowadays, halftone is more often applied digitally using a computer graphics application. Halftone should only be considered as a method of shading if you specifically want to achieve that mechanical-looking effect.

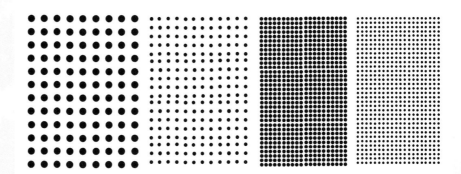

Top Tip

Shading and tone can be used simply as a background, to frame your cartoon and make it stand out.

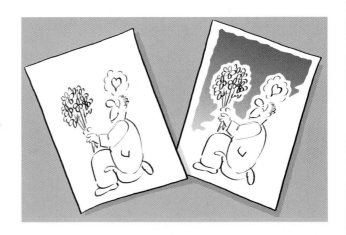

CONTINUOUS TONE

As its name implies, continuous tone, or as it is sometimes called, greyscale, covers the full range of greys from almost black to almost white. It is a form of tone we are all familiar with from black and white photographs. It is the richest and most detailed form of shading which, whilst it can produce the most dramatic effects of all, is actually often easier to apply than either hatching or mechanical tints. Cartoons using continuous tone are often referred to as "line and wash".

The term "wash" refers to the original method of applying this form of tone, with a brush, using diluted India ink. Though this is still a method used by cartoonists today, it does have a few drawbacks, namely:

• You need a different dilution of ink for each shade of grey.
• Your cartoon must be drawn with a waterproof medium to prevent the line from running or bleeding as the wash dilutes it.
• Because a wash is, by its nature, wet, it will cause the paper to wrinkle.

These drawbacks can be avoided by using a dry medium to apply the tone, such as pencil or charcoal, where the tones of grey can be varied by increasing or decreasing pressure. You can also buy greyscale marker pens from specialist art shops, but these are expensive and you need to buy a different marker for each shade of grey. They also tend to bleed when used on ordinary paper.

Nowadays, more and more cartoonists are using the computer to add continuous tone. If you already have a computer and a scanner this is by far the easiest and cheapest way to do it with the only drawback being that you end up with a print of your work rather than an original. The example above, despite looking like a traditional line and wash, was actually done with a computer.

Top Tip

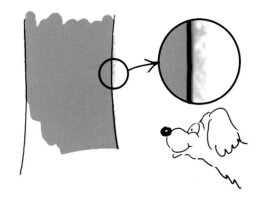

To minimize problems with bleeding, draw on a high quality paper.

TEXTURE

▼ Yet another way to apply tone is to use texture. This method takes advantage of the property of the paper you are working on; charcoal, pastel and soft pencil are just a few of the media you can experiment with, using a coarse-grain paper or a watercolour paper. As with using normal paper, the pressure you use will determine the depth of the tone, only more so.

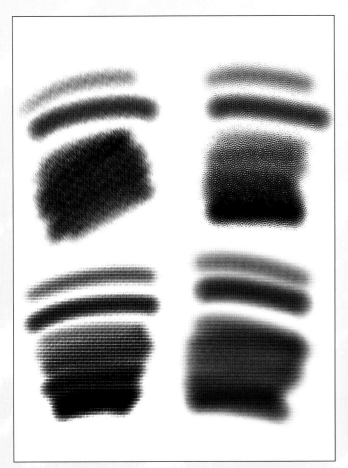

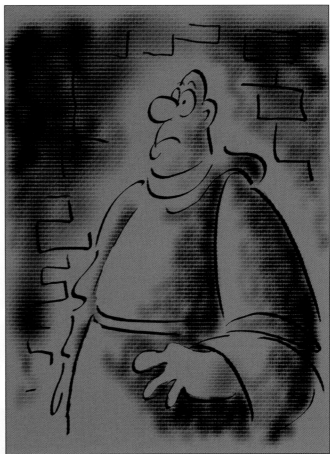

▶ When experimenting with these techniques, it's a good idea to try them on coloured papers, too. Look at the two examples shown right. In the second drawing a white crayon has been used to add highlights.

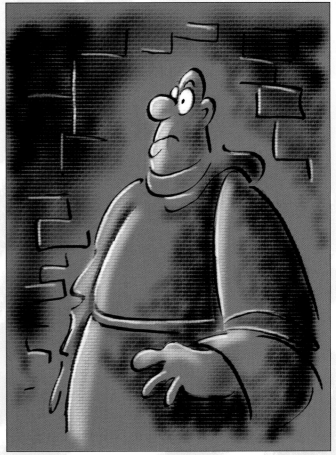

NATURAL TONE

Finally, before we move on to talk about the use of colour, don't forget that many of the things you include in your cartoons provide a natural tone that don't necessarily require any embellishment. For example, the pattern of bricks in a brick wall, the grain in a wooden fence and the leaves in a tree or hedge. And what about people? The clothes they wear can be given a pattern. Animals, too, with their many varied coats, provide their own tone.

COLOUR

Why use colour at all? Obviously by using colour you add something to the picture. If the logic is that every line in a cartoon serves the point, then colour must also serve the point or, in other words, make it easier to put that point across. The key reasons for using colour in a cartoon, then, are to help make the point, and also to make the artwork easier on the eye and lift it off the page.

From a practical point of view, one of the problems with black and white can be separating the various layers within a picture. The linework of the background and foreground can very easily get mixed up with the main detail of a cartoon. Using colour can help but if you don't get it right it can still all end in confusion!

Be aware, then, that every time you reach for a brush, a marker or whatever medium you decide to use, you are using colour to enhance the message not just to fill in a space. But what colour, what medium and where do you use it? In the end it will come down to personal choice and that is the way it should be. We all have differing tastes, and its likely that as you experiment with different mediums, one will become your preferred choice.

Hey! I thought I was the important bit!

WHAT MEDIUM?

Colour cartoons differ from paintings in that the black line is normally completed first and then the colour added over the top, with the black line showing clearly through. It is important, then, that the medium used for colour is completely transparent.

By far the most popular media are coloured inks, coloured markers and computers. Watercolours are not really an option because they are only semi-transparent and will dull the black line. You should also bear in mind that, as when using washes, your black line should be done with a waterproof medium.

▶ When you use inks or markers, you will notice an important and useful difference from working with paint. Because the colours are transparent, whenever you overlay them, a new colour will be created where they overlap.

◄ MARKERS

Markers are excellent for applying loose, flowing colour. Try to find a make that also has a blender which allows you to merge one colour into another.

Markers are also very good for applying flat colour, also known as spot colour. This is the favourite colouring technique of many comic and cartoon strip illustrators because of its uncomplicated and bold nature. It is a very simple technique in which each area of the cartoon is filled with a single colour, a little like painting-by-numbers without the numbers!

INKS

Inks allow more subtlety, especially because you can take the basic colours and dilute and mix them to create many different tones. They are also more difficult to master but the practice is well worth the effort. When using inks, avoid overloading your brush because excess liquid will quickly wrinkle the paper.

▼ Take a look at these two cartoons. Can you spot the difference? In the cartoon on the left the line drawing has been done in black. In the cartoon on the right some of the original line drawing has been done in colour. This can be very effective but you need to exercise your judgement and not overdo it. What do you think of the effect? Why not give it a try yourself?

Top Tip

As it's easy to spoil your artwork when applying colour with markers and ink, make copies of your initial drawing so that you can experiment boldly!

COMPUTERS

In recent years, many professional cartoonists and illustrators have turned to the computer for their colour work. There are many advantages for the professional, not the least being the fact that a large proportion of artwork is now delivered in digital format. The other advantages are equally applicable to the novice cartoonist:

• You never run out of ink or markers.

• Because you can UNDO work on a computer, you can truly experiment until you find exactly the effect you are looking for.

• You can print off as many copies as you want (if you are producing your own greetings cards, for example).

• You can zoom in and out of your cartoon, which is a great help when working in detail.

▼ Areas of colour can be block filled, not only in flat colour but in gradients, either from one tone to another…

…or one colour to another…

…fills can be textured…

…or even patterned

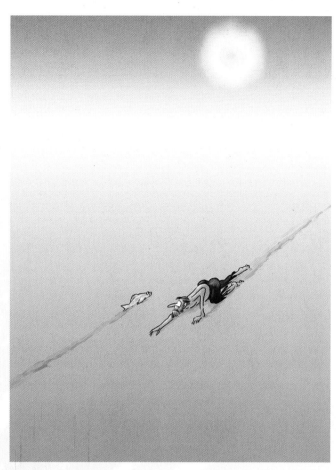

▲ This cartoon was drawn and coloured entirely on computer using a Wacom drawing tablet, pressure-sensitive stylus and Corel Painter software. The larger areas of colour have been done using gradient fills.

This has been just a brief introduction to the use of colour. The best way to progress is to look at as many examples of other cartoonists' colour work as you can – we all have tricks and we all borrow from each other in this respect. In particular, have a good look at cartoon greetings cards.

But don't just restrict yourself to the colour work of cartoonists; you can learn a great deal from looking at the work of illustrators and, indeed, fine artists. There is a world of colour illustration out there, in books, magazines, not to mention art galleries. Cartoonists rely very much on what they see and experience around them as they go about their lives and you can learn a great deal about the use and application of colour in this way.

THE BIGGER PICTURE

So far, we have concentrated on the subject matter of your cartoons and we will be returning to this. But first, briefly, let's literally consider the bigger picture – layout, background and perspective.

LAYOUT

Whether you are drawing for your own pleasure, for your family and friends, for a website, personal greetings card or hoping to see your work in print, the presentation of your cartoon is very important.

One of the most common mistakes beginners make is to draw right up to the edge of the paper, but professional cartoonists will always leave a good margin right around the drawing. There are two reasons for this. Firstly, it is necessary to leave space around a cartoon so that editors can make any special notes, such as the finished size, for the page layout designers. If you are not planning to sell your work then this will obviously not apply to you. However, the second reason for leaving a good margin applies to everyone.

▼ A clear space around a cartoon actually improves the way it looks. Look at these two examples below. It is almost as though a frame has been put around the second cartoon and, just as a frame sets off a painting, a margin nicely sets off your cartoon.

"1... 2...3......?

"1... 2...3......?

Another layout factor you should always consider is the balance of the cartoon. This means the way in which the content of the cartoon is distributed on the page.

▲ Although the images in this picture are symmetrical and centred, there is something about the layout that doesn't quite look right.

▲ A quick rearrangement of the various elements that make up the cartoon immediately makes it look more visually interesting.

Sometimes a cartoon gives you the feeling it is out of balance even though you can't quite put your finger on the reason. A trick-of-the-trade, in these instances, is to hold your cartoon up to a mirror. Amazingly, you will see, instantly, what is causing the trouble.

There are a lot more factors to consider in good layout, but these are the basics. One last thing to remember, though. Empty space is not necessarily wasted space. You should not try to fill every tiny bit of the paper, simply because you can. Sometimes, what you leave out from a cartoon is just as important as what you put in.

▼ Here's an extreme example that illustrates the value of empty space on the paper. The empty space is crucial to the humour in this cartoon.

"You've got a lovely big garden."

BACKGROUND

Most cartoon subjects need a setting, a background. Another common beginner's mistake is to make the background of a cartoon too dominant so that it swamps the main subject matter. This could be because the heaviness of the line of the background is equal to or outweighs that of the main subject. Similarly, if the background is too complex, you get the same result.

▼ In this example the background has been drawn with a heavy line and it is also detailed and complex. It's hard to see what is going on.

▼ With a lighter and simpler background the main subject of the cartoon is much clearer. Note also another trick of the trade is to keep a narrow white space all around the main subject so that none of the linework of the background comes into contact with the linework of the subject material.

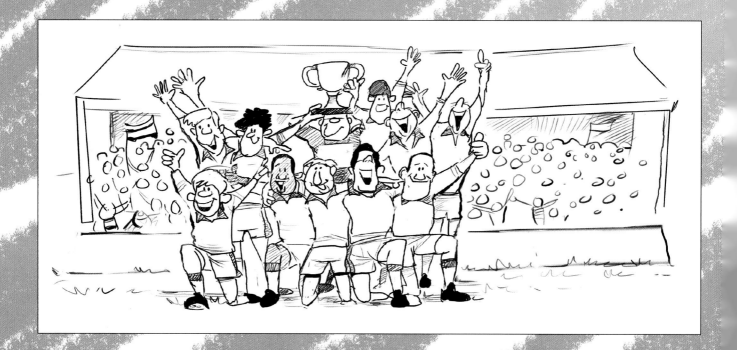

PERSPECTIVE

You will need to get to grips with and develop a basic understanding of perspective, otherwise your cartoons will look flat and two-dimensional. Don't worry, it's a much less painful process than you might think!

Perspective is, of course, something that we are all familiar with. It's the natural way the eye sees things, making characters and objects close-up seem larger and those further away seem smaller. In cartoons perspective doesn't have to be perfect but it does need to keep at least one foot in reality.

▶ This cartoon is a great example of how perspective makes cartoons look three-dimensional. Notice how the figures in the background appear smaller and that the pavement recedes into the distance. This is, of course, how you would see this scenario in real life.

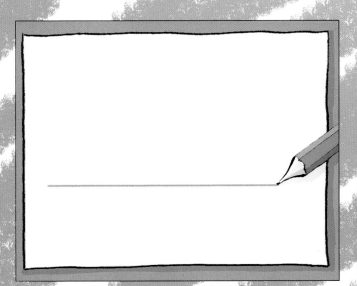

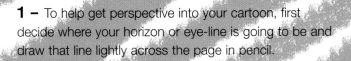

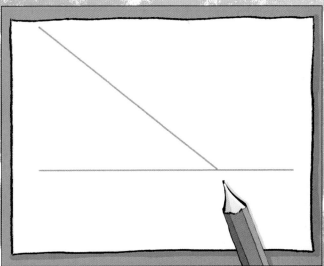

1 – To help get perspective into your cartoon, first decide where your horizon or eye-line is going to be and draw that line lightly across the page in pencil.

2 – Next, draw pencil guidelines from where the highest (nearest) points in your cartoon will be, to the vanishing point (or points). This line represents the way objects will diminish in size, right down to nothing as they get further away.

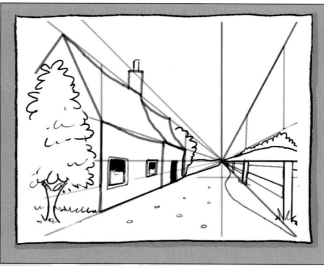

3 – You can now add other pencil guidelines, providing you with a grid on which to base your three-dimensional cartoon.

4 – Once you've added in your pencil guidelines, start drawing your image. You can add more guidelines while you're drawing if you feel they're necessary.

Top Tip

There are two things that you should remember.

▶ First, a vanishing point doesn't have to be on the paper, it can be much further away. You can either mark it on your drawing surface or simply, with practise, guess where it is.

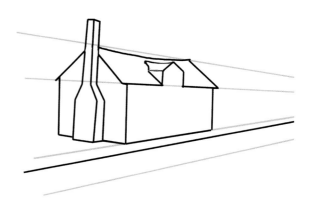

▶ Secondly, a vanishing point can be above the horizon or eye-line.

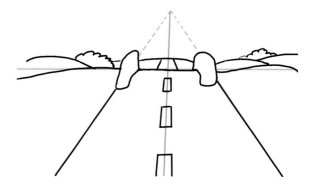

Once you have had some practise with perspective, experiment with placing your horizon/eye-line at different heights. By changing this point of view it is possible to dramatically change the way your cartoon looks, as you can see demonstrated in the three versions of the same cartoon scenario on this page.

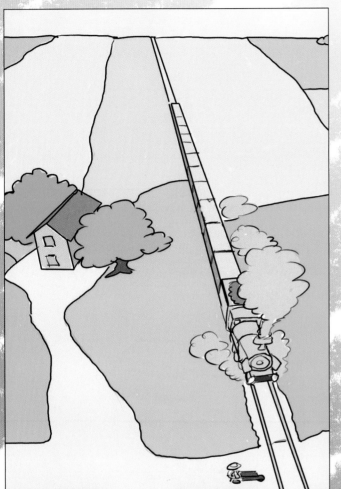

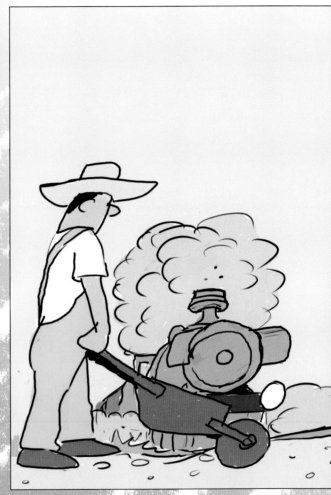

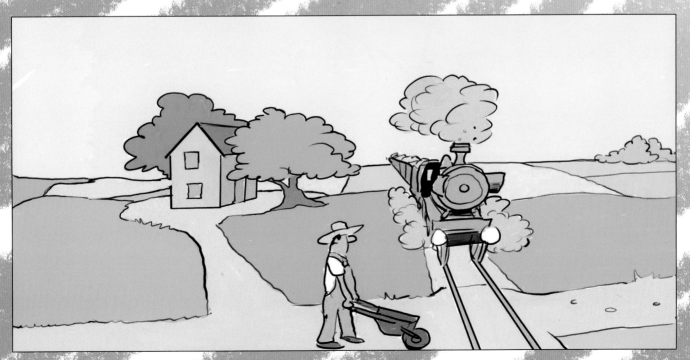

INANIMATE OBJECTS

We mentioned, right at the beginning of this book, that the rules applied to cartooning people and animals also apply to drawing inanimate objects. A method that you may find helpful in drawing these objects is also one that we applied earlier when discussing the drawing of animals (see pages 28–29). As with animals, you should look at an object and break it down into its geometrical components. Here are a few examples to get you started. ▼

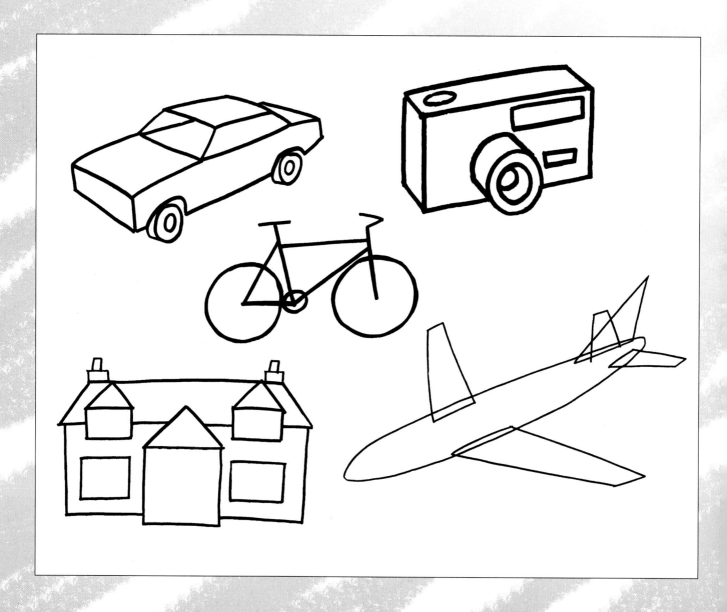

CHARACTER DEVELOPMENT

In the hands of a cartoonist, an inanimate object can entertain aspirations that its counterparts in the real world would never dream about (well, if they could dream that is!) Yes, we are talking about our old friend anthropomorphism, where an inanimate object may not only dream but also acquire arms, legs and other appendages.

Turning these objects into cartoon characters is what professional cartoonists call "character development" and you see the results of their handiwork all around you in newspapers, magazines and on posters and television. Talking telephones, frolicking fruit, all brought to life by the skill of the cartoonist.

But let's not dwell on these commercial aspects because these special characters are great fun to draw in their own right and definitely deserve a place in your cartooning repertoire. We'll start off with a very basic example – a simple tin can. Give it a face and we're already off the mark. ▼

▼ We'll look at variations in facial characteristics in just a moment, but first let's give our character some more personality of his own with the addition of arms and legs.

Already you can see that our basic tin can is coming well and truly to life. You may have noticed that this sense of animation comes not only from the human attributes, but from the flexible way in which the can has been drawn. By slightly curving the straight lines you take away all of the subject's original inanimate nature and transform it into a living creature.

Now we can examine in more detail the way facial expression can be used to even greater effect than on a human cartoon because we have so much more space to play with. There are lots of examples on pages 78–79.

The quizzical look. Eyes and nose are grouped at the top with the eyebrows actually floating above the image.

A variation on the previous example. All we have done is move the mouth down to the bottom. A very small change but a big difference to the cartoon as a whole.

Next, dropping all the other features further down to join the mouth emphasizes the quizzical expression.

We are already seeing a lot of variation using the same size features. Now see what happens when you reduce the size of the various features in relation to the main body.

And again, as the ratio between features and body increases.

Alternatively, see the difference made by greatly increasing the size of the features and notice, also, how large eyes and small eyebrows add another dimension to the expression.

We could go on and on because there are so many permutations. Better, though, to leave you to play around with them on your own, working out your own variations, moving features around (don't forget the ears, too) and generally discovering the many personalities you can create with just a few strokes of the pen.

◄ Once you have got your character looking the way you want him to, you can start to add other bits and pieces too such as shoes and clothing.

OTHER CHARACTERS

A tin can is a very straightforward shape, which is why we used it as our basic example. When you want to anthropomorphize something more complex, the trick is to look at the special features of your subject and use them to your advantage. Here are a few examples to start you off.

The sole of the boot peeling away from the upper makes a perfect mouth, especially when the exposed nails resemble a row of ultra sharp teeth. The front of the boot becomes the nose, enlarged lace-holes become eyes and the laces make suitably villainous eyebrows.

As the "mouth" of the vacuum cleaner sucks, the bag provides a pair of wonderfully bulging cheeks.

Having turned the spanner into a predator, it is only natural to depict its prey as a nut - and it's a happy coincidence that the hole in the nut makes a perfect, terrified "o"-shaped mouth.

Turning the headlights of the car into eyes is a fairly obvious choice. Making eyebrows from the windscreen wipers takes a greater leap of imagination, but works brilliantly when put into practice.

Our washing machine has been given a different treatment. The nose, eyes and tongue may not immediately be obvious but once you make the imaginative leap, everything falls into place.

The features of a radio/CD player lend themselves to adaptation very well. As with the car's headlights, the speakers are a clear choice for the eyes.

The towel lolling out of the golf bag's zipper mouth is another example of thinking beyond the obvious. The clubs work well as eyes but they could be equally convincing dog-style ears.

STRIPS

The strip cartoon comes in many forms, the most common being the sort we see in our newspapers. These are usually simple black and white strips, comprising three or four panels. Other forms range from the double-decked, full colour strips often seen in the cartoon supplements of some Sunday newspapers, through to full-page comic strips with many frames. The graphic novel is also a form of comic strip – it's a strip that fills a whole book. For the purposes of learning the basics however, we shall concentrate on a three-framed strip.

One of the most popular forms of cartooning, the strip cartoon is the first thing many beginners attempt. Unfortunately, the results are usually far from satisfactory, and the main reason for this is that despite its apparently simple layout, the strip cartoon is a much more difficult format to work in than that of single panel cartooning. For one thing, you have a lot less space in which to work. Not only do you have to fit three or four panels into the space that one or two single panel cartoons would take up, but by the nature of a strip cartoon, you have a lot less "headroom" to work with.

Another problem is that the dialogue, usually in the form of speech bubbles, has to be fitted into each of the frames, thus encroaching on valuable drawing space and making forward planning an absolute necessity.

The time spent learning to overcome these problems is, however, well worthwhile because strip cartooning can be very satisfying and rewarding – and a lot of fun.

The one big advantage that the strip cartoon has over the single panel cartoon is that it allows the cartoonist to develop a storyline at his or her own pace. In a single cartoon every element must be included in the one drawing, whereas in the strip cartoon elements can be introduced frame by frame.

▼ To begin, before putting pen or pencil to paper, you must work out your storyline and in particular, the dialogue. Rough out your three frames in pencil and then work out where your speech bubbles are going to go.

You will almost certainly need to do this a few times before it works properly, bearing in mind that the speech bubbles should not dominate the frame. You may have to take on the role of a harsh editor, and cut down on some of the text, especially where you have more than one speech bubble in a single frame.

Incidentally, when you do have more than one speech bubble in a single frame, be sure to put the one that has to be read first on the left. This, in turn, will dictate where the characters are to be placed in the frame, so you can already see why planning ahead is a must.

▼ Once you are happy with your text layout, use your pencil to rough out the whole of the cartoon. At this stage you may discover that things won't fit in the way you want them to, in which case further revision and editing of the text will be necessary. Keep working on it until you are happy with the result. Notice that in this example each of the frames, or panels, has now been made into a separate box. In the first text rough shown on page 82 the boxes were joined together. Keeping each frame separate is important for the majority of strip cartoons.

▼ If you are still finding it tricky to fit your text in, you can use a technique called "breaking out", where a speech bubble in a crowded frame is allowed to overlap into a less crowded frame next door. This example shows how this can work. It can be a very useful technique to employ.

▶ If you are happy with both your text and drawing layout, it's time to take the plunge and ink in the finished cartoon. Take particular care with the lettering – which is really a skill in itself – because legibility is a crucial factor in good strip cartooning. If lettering isn't your strong point, don't worry – stick to block capitals, write neatly and legibly, and it will look fine. Some people find it helps to use a ruler and pencil to draw faint guidelines for the lettering to sit on, which can be erased later.

▶ Because a strip cartoon is set in boxes there is a danger that it could look a little regimented. There are several things you can do to counter this. You can vary the size of the boxes, as we have done in the example above. You can also remove one of the frames altogether, as shown in this example, because the two frames either side naturally frame the centre one. Also, as shown in the first panel you can make the speech bubble break out of the frame.

▶ Another thing you can do to change the look of your strip is to delete the speech bubbles and have your text floating in the frames. This does make things a little more difficult though, because you can no longer use the breaking out technique and you must be careful not to allow the drawing to encroach on the text.

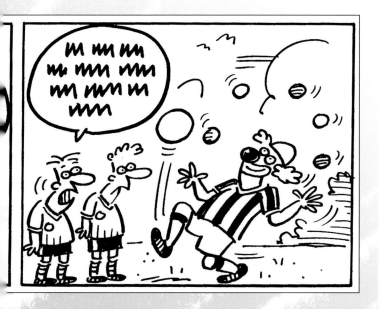

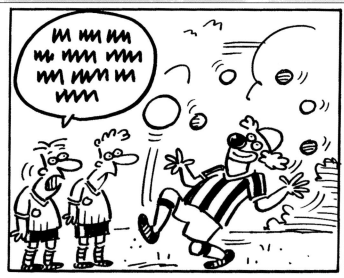

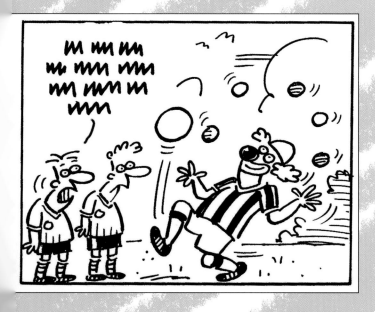

Top Tip

To save time measuring and drawing the outer frame shape, make a template that you can draw around with a pencil.

TEXT SIZE

▶ As we have already said, the dialogue in a strip cartoon must be comfortable for the viewer to read. Because a strip frame is so much smaller than a single panel cartoon, there is a limited amount of space available so try and make the most of it. In the first panel the text is trying to burst out of the speech bubble, which makes it uncomfortable to read, as is the small text in the second panel. Getting it just right, as shown in the third panel, is the result of careful forethought and planning.

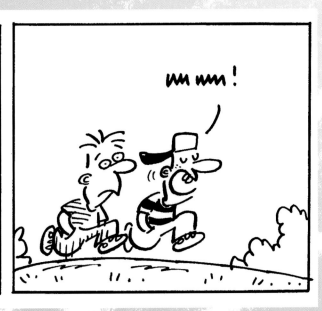

AND FINALLY...

◀ You should always be thinking of ways to make your strip cartoon look instantly visually interesting, so that the viewer is hooked even before they have examined the content in detail. Many would-be strip cartoonists fall into the trap of making each frame very similar to the previous one, as shown here.

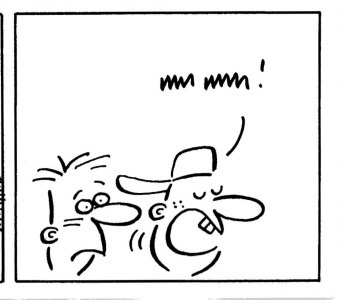

◀ Do as much as you can to vary the content of the frames in ways similar to the third example. Notice too how the horizon line has been kept very low in these examples. This is generally a good idea when working in many different cartoon formats but especially so in strip cartoons where you have so little space in which to work.

We have really only examined the tip of the iceberg where strip cartooning is concerned, but the best place to learn more is from published material. Look through the newspapers and note the amazingly varied techniques used. Some of the techniques may be quite subtle but as you are specifically looking for them you are sure to be able to spot them. Include the ones you like in your own repertoire.

EXERCISES

These exercises are intended to help you try out your cartooning skills and show you how to examine and evaluate your own work. Once you are happy with what you've drawn, you should read the relevant "How Did You Do?" assessment on pages 90–91. Please read through each exercise carefully before starting to draw.

Before you get started, here's a suggestion for you. When you have completed an exercise, don't turn straight to the "How Did You Do?" pages. Leave your drawings for an hour or so – even a day, if you have the patience – and then take another look. Assess what you've done and make sure you are reasonably happy with it. If necessary, redo the exercise but don't discard your first attempt. It's useful to compare earlier versions with revised ones.

EXERCISE 1

Draw two cartoons:

1 – Two neighbours are talking to each other over the fence or small hedge that separates their gardens. The subject of their discussion is a strange plant that is growing on one side of the fence or hedge but which is now straying over on to the other side.

2 – A very stern official and a nervous traveller are talking. The official has demanded to see the traveller's ticket but the traveller has clearly lost or mislaid it.

When drawing these two cartoons, show the people from the waist up and keep background detail to a minimum.

EXERCISE 2

Draw two cartoons:

1 – Six people are waiting at a bus stop. The bus has not yet arrived but everyone is quite relaxed and clearly not worried.

2 – The same six people, some time later. The bus has not arrived and they are beginning to show signs of impatience and even anger.

EXERCISE 3

Draw two cartoons:

1 – A standing figure that is very happy.

2 – A walking figure that is totally depressed.

EXERCISE 4

When we last saw the people waiting for their bus, they were starting to become impatient and angry because the bus was late. Now several more minutes have passed and the bus has finally arrived. But guess what? It has gone straight past the bus stop and the waiting people without stopping.

Draw the six people chasing after it down the road (but don't draw the bus).

EXERCISE 5

Draw a character lifting a very heavy load.

EXERCISE 6

Using any of the shading methods described on pages 59–65, draw a few simple three-dimensional objects. You might draw a cone or a cube but include an irregular shape too, such as a rock.

EXERCISE 7

Draw two versions of the same cartoon, one set in the daytime and one at night, using the shading method of your choice.

EXERCISE 8

Draw two cartoons:

1 – Choose one or more inanimate objects and turn them into living cartoon characters.

2 – Do the same again but this time use animals instead of inanimate objects.

HOW DID YOU DO?

This is where we help you to examine your own work and judge how well you have followed the brief that was given to you. You will notice that we are not showing you any examples in this section. The reason for this is twofold.

Firstly, there is no absolute and definitive right way to do these exercises and anything we show you would only be one of many ways to tackle them. Secondly, now is the time for you to fly solo, make your own mistakes and, with the help of the pointers we give you, set about putting them right. If you didn't make any mistakes, well done, you are pretty unique! Even so, nothing is perfect and every cartoon can be improved. Let's go through the work you have done (please do not read any of the comments referring to exercises you have not yet done as this would significantly reduce the benefit of doing them).

EXERCISE 1

Do the expressions on the faces of the characters clearly reflect their feelings in the situation? Did you draw the hands or did you hide them? If you drew the hands, do they supplement the facial expressions, making good use of body posture or are they just there as pointless decoration?

In both of the cartoons, the situation is likely to be one of confrontation and this should be clear from the expressions (and hand gestures) you drew.

In the case of the first cartoon, the conversation between the neighbours is centred on the plant that is encroaching. It could be that one neighbour is angry and the other apologizing. Perhaps, instead of apologizing, the plant's owner is reacting angrily to the other's complaining. Perhaps, even, there is no confrontation and the plant is simply being admired.

It really doesn't matter as long as, when someone else looks at your cartoon, they see what you intended them to see. In fact this is a test you should carry out for all of these exercises – ask a third party to look at your work and describe what they see. It is surprising how often we see things in our own work that is actually still in our own head and not on the paper!

EXERCISE 2

Have you drawn an interesting selection of people – different ages, height, sex, race, etc.? Did you draw the people straight across the page or did you look at them from an angle using perspective? Did you think to make one of the characters a baby in a pram or pushchair? Are the characters doing something else whilst waiting for the bus and, if so, how does this develop in the second cartoon as they become impatient?

What we are looking for here is variety. Drawing very similar characters in a two-dimensional way makes your work look static and boring, and lacking in depth. It also helps if you give your characters something to do, such as reading a newspaper or listening to music through earphones. In the first cartoon, these props help to establish that everyone is relaxed and reasonably happy but in the second cartoon these props come in useful to show the onset of impatience – perhaps the newspaper is no longer being read but is rolled up and being tapped against the other hand or a leg.

Finally, in the second cartoon, remember that these people are waiting for a bus to arrive. The bus is late so at least one of the people should be looking down the road to see if it is coming and at least two should be discussing it.

EXERCISE 3

Is your happy person simply happy? Is your depressed character truly depressed?

Because cartooning is often about exaggeration, it is very easy to go a little too far and lose sight of the effect you are striving to achieve. A happy person can unintentionally become deliriously ecstatic whilst one who is supposed to be depressed can look sullen or even angry. Neither of the latter are traits of depression and the character should show a certain purposelessness and a total lack of interest but without looking merely bored. These are not easy things to get right first time but if you keep in mind exactly what your character is feeling you can achieve the right result in your drawing.

EXERCISE 4

Did you draw the bus? Are the people obviously chasing something or does it look as if they are simply having a race?

You didn't draw the bus? Well done. The bus was not the point of the exercise and, in any case, we asked you not to draw it in the brief. If you did draw the bus you are not alone. It's easy to miss something, or forget it when you want to get down to drawing.

As far as the running people are concerned, you should have made good use of any props you used. Newspapers should be waved, earphones or hats should be flying off the head. All eyes should be focussed down the road, fixed on the (invisible!) disappearing bus.

EXERCISE 5

Is your person really lifting the weight or just giving it a cuddle?

This is a very good exercise for using facial expression and body posture. You should have brought all your skills to bear on this one: eyes screwed up, teeth clenched, beads of sweat flying, arms stretched to their limit and beyond, legs buckling and wobbling, whole body shaking. Even the hair can come into play. If you got half of those things into your cartoon, well done!

EXERCISE 6

Do your shapes really look three-dimensional or are they just flat shapes with texture?

The object of this exercise is to achieve depth in your drawing. If it hasn't worked first time don't be surprised – getting shading right is something that does take a lot of practise.

EXERCISE 7

Does your daylight version look as though it could be night? Can you see what is going on in the night version or has everything become lost in a mire of overzealous shading?

We make no excuses for repeating that, with shading, less is usually best. If you answered "yes" to either of the above questions you have allowed yourself to get carried away with shade and tone. It's a matter of self-discipline and, yes, more practise!

EXERCISE 8

Have you truly breathed life into your characters or do they still look like inanimate objects with faces, arms and legs? Do your anthropomorphic animals still retain some of their natural characteristics or do they look like human bodies with animal heads?

With your inanimate objects there is more to giving them life than simply adding eyes and tacking on a few limbs. You should be using everything you learnt about expression and body posture here. Similarly, you should have made use of any natural characteristics that your object possessed that could be developed into human or animal characteristics.

And talking of animals, giving them human characteristics doesn't mean you have to throw away the ones that they already possess. You should take the animals' natural characteristics and adapt them rather than discard them.

WHAT NOW?

Even if you set off down the cartooning road with a view to drawing cartoons for your own amusement only, you have probably learned, by this time, that cartoons demand a wider audience. Draw a good cartoon and the urge to show it to someone is almost irresistible – and there is nothing quite like the feeling of seeing someone looking at and clearly enjoying a cartoon that you have produced. So what are the options open to you?

Friends and family make good and accessible targets for cartoons, and a personal greetings card with a cartoon design is appreciated a lot more than one bought from a shop. Maybe you know someone who produces a newsletter for a local club, society, church, etc.? If so, they would almost certainly welcome the idea of an appropriate cartoon to both amuse their readers and to break up large areas of text.

Websites are another place where cartoons can play a big part. Many people have their own personal websites – maybe you have one yourself – and a good helping of cheerful cartoon illustrations can make a huge difference to the way it looks.

All these are good and satisfying ways to use your cartoons and bring them to a wider audience. But, maybe you have even bigger ambitions for your work. Maybe your dream is to sell your cartoons. If that is the case, where do you start?

Let us start by saying that selling cartoons is not easy, and as well as talent you will need a good supply of determination and perseverance. That being said, the rewards of selling your cartoons are wonderful – not just that useful extra cash but the pleasure of knowing your work is being seen by thousands of people. So, how do you get your foot in the door?

Perhaps the best way to get started is in your own area. For instance, if you have a local newspaper that doesn't usually include cartoons, have a go at drawing something on a topical local subject and send it to the editor. If the editor likes it – and prints it – that is your cue to approach him or her with the suggestion that you could produce a regular cartoon, for a reasonable fee, on local issues and topics. Although newspapers can buy general syndicated cartoons quite cheaply, there is nothing quite like a cartoon drawn exclusively by someone (you!) who is familiar with all the things that are going on in your region. Your work will be original and right up-to-date.

SELLING GAG CARTOONS

Selling gag or joke cartoons is probably the main ambition of most would-be cartoonists who want to see their work in print. The problem is that there is usually a lot more supply than there is space to print.

Obviously, in order to sell, your work needs to be funny and well drawn but beyond that you need a little bit of luck. However there is an old expression that says you make your own luck and there is a lot of truth in that. Many good cartoons fail to sell simply because the cartoonist went about it the wrong way. So here are a few pointers to help you avoid the pitfalls of selling a gag cartoon.

• There is no point in sending just one cartoon to a newspaper or magazine. You should make up a set of at least six finished cartoons for your submission.

• Make sure your cartoons are nicely presented, with a good margin of white space all around and any captions written outside the area of the drawing.

• Design a professional-looking letterhead for yourself upon which all of your contact details are printed and use this to write a short note to the editor. Keep it simple – something along the lines of: "*Dear* (find out the editor's name if you can), *Please find enclosed six cartoons for your consideration.*" Remember, editors are busy people and they don't have the time to read personal letters enclosed with submissions detailing cartoonists' life stories and ambitions!

• Always enclose an appropriately stamped and addressed return envelope.

• Use a cardboard stiffener in your envelope to protect your cartoons from the dangers of the postal service!

• Research your market and read a few copies of the newspapers or magazines you are submitting to so that you know that what you are sending is suitable. You may have come up with a beautifully drawn, fantastically funny cartoon about knitting but it would be pointless sending it to *Extreme Snowboarding Monthly!*

• Finally, if you want to sell cartoons, you will inevitably come up against the dreaded Rejection Slip! The best way to deal with this is to remind yourself that every professional cartoonist faces rejection as part of his or her job. Rejection is never personal and the reason most cartoons are rejected is simply because there is not enough space in the publication. Keep this in mind, keep trying, and eventually you will achieve your goal.

INDEX